Pastel

Course of Drawing and Painting

Author: Josep Casals
Artists: Badalona Ballestà, Rogelio Urgell, Julia Romero
Editor: Nacho Asensio
Coordination & texts: Rosa Tamarit
Translation: Bill Bain
Graphic design & Layout: David Maynar / Mar Nieto

Copyright © 2004 Atrium Group
Published by:
Atrium Group de ediciones y publicaciones S.L.
Ganduxer, 112
08022 Barcelona

Tel: +34 932 540 099
Fax: +34 932 118 139
e-mail: atrium@atriumgroup.org
www.atriumbooks.com

ISBN: 84-96099-60-1
Legal Dep.: B-47.139/2004

Printed in Spain
Ferré Olsina S.A.

Contents

Introduction

Although some artists had already used similar materials to draw with, pastels became popular with painters during the 18th century. The acceptance of this medium by painters led to a large number of artists adopting it as a material and it even came to compete with oils. Great artists who habitually used pastels in their works were Degas, Manet, Odilon Redon and Picasso among many others.

According to the artist's intention, pastel can be used to produce works that can either be considered pure drawings or complete paintings. On the first pages of this book, the reader will find an extensive range of products some of which are absolutely necessary to develop the technique and others that are accessories. It is not necessary for the enthusiast to acquire all of the materials listed; the important thing is for him or her to be familiar with them so as to be able to decide which uses and practices are most adequate in each case.

1 Pastel

Pastel is made up of pigment and a small amount of chalk pressed together with gum arabic. With these three products, a paste is formed that is later modeled and left to dry. The composition of pastels is, therefore, one of the simplest of all of the materials used by the artist.

Materials

Pastel is a material that can be applied in the same way as any other habitually used in drawing. In fact, the first techniques that are dealt with in this book are very similar to those applied to drawing with charcoal and sanguine crayons. In order to start painting, one or two pastels and a sketch block that can be acquired at any art suppliers will be enough.

THE RANGE OF COLORS

Pastels contain a neutral component that allows the stick to acquire certain hardness. This element may be gypsum, whiting or even chalk. Initially, although these elements are completely white, they do not have the qualities of pigments; that is to say, in order to avoid the negative effects of the mixtures, the pastels are fabricated in such extensive ranges that a large variety of tones exist for each color.

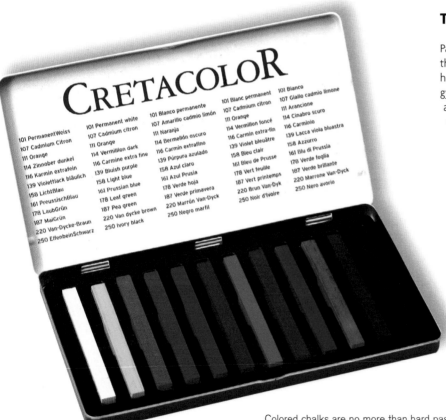

Colored chalks are no more than hard pastels with a very restricted range of colors. Hard pastels permit more highly defined lines to be drawn although they are not as versatile as the soft ones. It is more difficult to spread out hard pastels than soft ones. Nevertheless, hard pastels are ideal for profiling and establishing details.

Oil pastels are denser and greasier than normal ones. They can be used for all aspects of the medium although it is difficult to spread them out with uniformity. As they are made with oil instead of gum, they can be mixed with oil paints and a variety of effects can be obtained when they are reduced with turpentine.

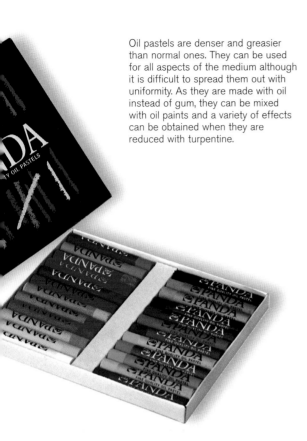

The cleanness of color is lost when pastels are mixed. This is because the component of chalk that gives stability to the stick is revealed and this reduces the luminosity and freshness of the medium. This image illustrates what has been commented upon.

OTHER PRESENTATIONS

These artistic materials are presented in many different ways. Given that some artists desire a highly personalized choice of colors, art suppliers tend to offer extensive ranges of possibilities. Other painters, on the other hand, adapt perfectly to a more conventional range.

Not all types of pastels are available in extensive prepared ranges; some large caliber, or thick, pastels are available in a very limited number of colors. In addition to pastel sticks, there are also pastel pencils. These have the same characteristics as pastels in stick form and can also be used as if they were normal pencils.

Pastels

Here we can see how oil pastels are mixed with linseed oil.

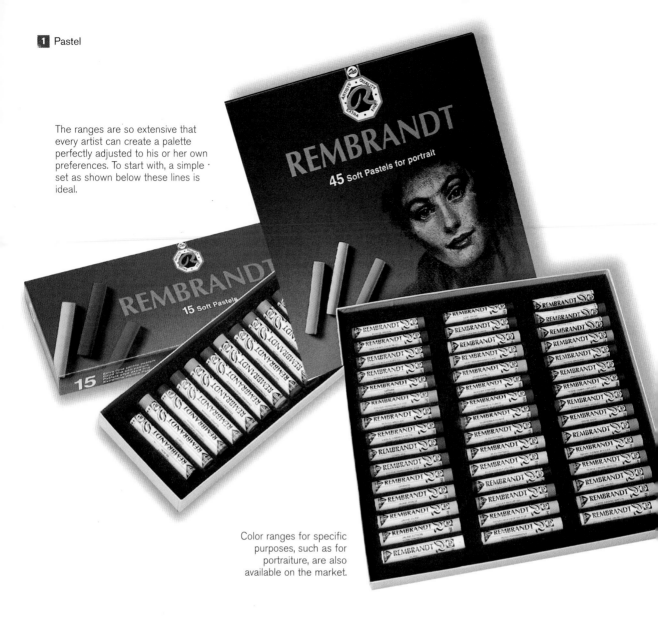

The ranges are so extensive that every artist can create a palette perfectly adjusted to his or her own preferences. To start with, a simple set as shown below these lines is ideal.

Color ranges for specific purposes, such as for portraiture, are also available on the market.

Thick Pastels. This is not the most usual presentation. The caliber overpasses the normal diameter. They tend to be manufactured in high quality materials in very limited color ranges and with prices proportional to their mass. These pastels are used by professionals who are attracted to large formats and who use gesture in their work.

Special Colors. Nowadays, all colors, including fluorescent ranges, gold and silver, are manufactured. These pastels, unlike other artistic mediums, provide clean luminous colors.

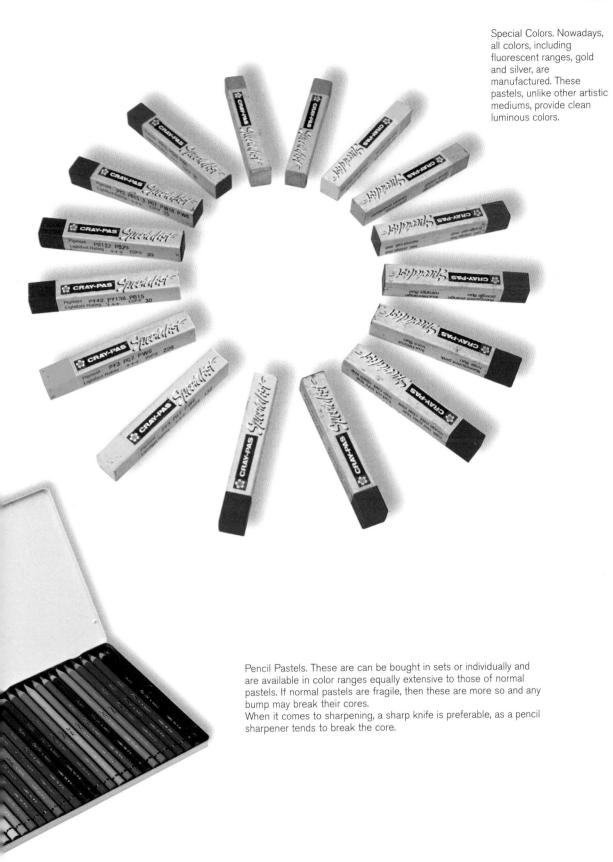

Pencil Pastels. These are can be bought in sets or individually and are available in color ranges equally extensive to those of normal pastels. If normal pastels are fragile, then these are more so and any bump may break their cores.

When it comes to sharpening, a sharp knife is preferable, as a pencil sharpener tends to break the core.

CLEANING

When the enthusiast starts painting, the first thing that he or she notices is that pastels break very easily; the sticks that have just been taken out of their brand new case in which they were perfectly ordered, have become a mountain of little bits that dirty as they come into contact one with the other. In the technique of pastels, cleaning is fundamental, as much for the pastels as for the artist's hands.

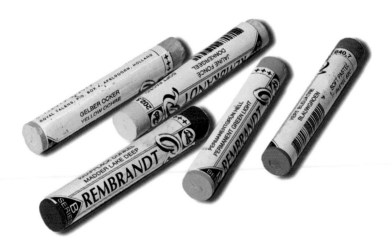

In order to avoid the colors dirtying one another, it is advisable to clean them before use. When a small number of pastels have to be transported, it is best to carry them in a box with grains of rice as the rubbing of the rice against the pastels, produced by the movement, keeps them clean.

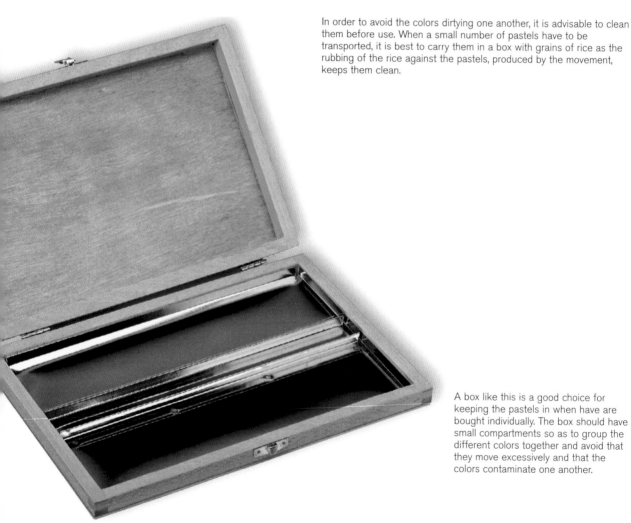

A box like this is a good choice for keeping the pastels in when have are bought individually. The box should have small compartments so as to group the different colors together and avoid that they move excessively and that the colors contaminate one another.

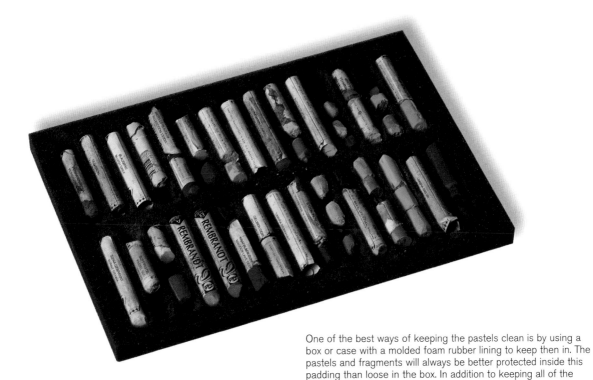

One of the best ways of keeping the pastels clean is by using a box or case with a molded foam rubber lining to keep then in. The pastels and fragments will always be better protected inside this padding than loose in the box. In addition to keeping all of the colors on view, the sticks do not dirty one another so much.

Cleaning

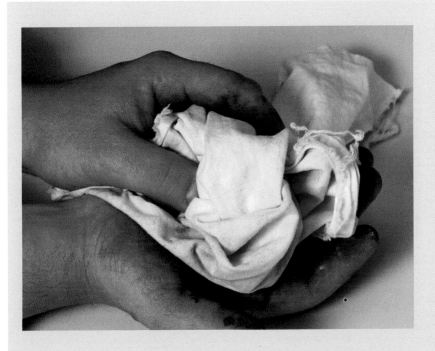

The enthusiast will soon notice that pastels are a completely unstable medium. The technique allows for the lines drawn to be smudged over the paper with one's fingers. The colors can also be dirtied with the same ease. For this reason, from the first moment, it is important to have a cloth at hand to keep your hands clean.

MANUFACTURING A PASTEL

An understanding of this process will help appreciate the quality of the pastels we use. As with any painting technique, it is important for the artist to be fully familiar with how the medium he or she is using has been elaborated. It is also desirable for the artist him or herself to be able to make his or her own paints should he or she so wish. In general, the elaboration of paints does not tend to be a difficult task, but it can become laborious and, unless one possesses a certain experience, the results may not always be those wished for.

The procedure outlined here can be followed if remains of pastels are being used. That is to say, fragments which can no longer be used to paint or draw with. The pastel remains are pulverized in a mortar without adding too much chalk and the resulting solution is mixed with a soupspoonful of water along with two drops of gum arabic.

VARIOUS SUPPORTS FOR

PASTELS

Pastels are generally used on paper. This is more of a custom than technical imposition given that, in reality, the medium can be used on any support. Although the majority of the exercises proposed by this book are to be worked on paper, it would by means be a mistake to consider other supports on which attractive results can also be obtained with the same faithfulness as those obtained on paper.

Pastels on Cardboard

Cardboard is economical and even free when recycled from packaging. On more than one occasion, any enthusiast will have thrown away cardboard boxes of various types: undulated, card, composed, feather card, etc.

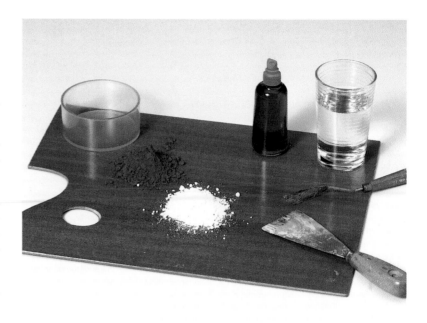

1. In order to make a stick of pastel, the following utensils and ingredients are necessary: spatula to mix the paste (1), spatula to mix in the color in the recipient (2), recipient in which to make the medium (3), the pigment with which you want to obtain the color (4), chalk filler (5), gum arabic (6), water (7), and a flat surface (marble, glass or a large painter's palette) (8).

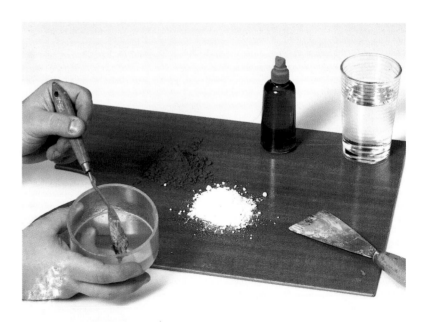

2. In the recipient, the medium that is to bind the pigment is elaborated. This medium is composed of water and gum arabic. The approximate proportions are a few drops of gum arabic for each soupspoonful of water. However, not all of the colors require the same proportions. A sufficient quantity has to be mixed so that the gum and water form a homogeneous mixture.

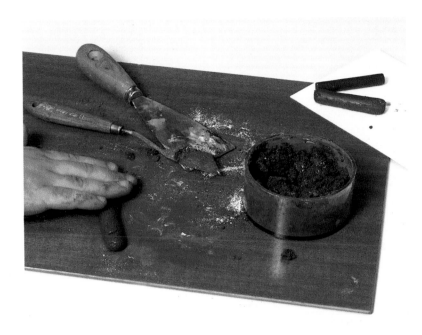

3. The chalk binder is mixed with the previous solution. If the mixture is dry, water will have to be added until it is smooth. The color is mixed in by adding the pigment to the former mixture. The purity of the pastel will depend on the quantity of color that is added to the mixture. If an excessive amount of binding chalk is added, the stick of pastel will be quite brittle. Once the mixture has been modeled into the form of a stick, it is placed on a piece of paper and left to dry for a few days and then, it will be ready for use.

The surface of cardboard is very porous and absorbent. As a result, the pastel sticks to it perfectly. Also, the thickness and the color of certain cardboard can lead to the luminous pastel colors standing out for their purity.

Painting on Wood and Cardboard.

Wood, above all tablex, offers an ideal surface to paint on with pastels. The advantage of this support is the rigidity of its surface and the peculiar texture that it has. Another of the rigid supports that best adapt to painting with pastels is cardboard. This can be acquired at art suppliers and is available in a great variety of sizes.

Prepared Canvases

Art suppliers offer a notable array of prepared canvases ready to be painted on. These are sold by the centimeter or already fixed on stretchers. For works in pastel, it is best to buy the canvas unstretched and use it as if it were paper. In order to paint on canvas or on paper, a board and drawing pins, clips or sticky tape are necessary.

PAPER AS A SUPPORT

As pastel is an opaque and dry medium, it can be used, as we have seen, on a great variety of supports. However, without a doubt, it is paper that has the greatest number of advantages. Paper as a support for pastel can be of any type although the most recom-

mendable are those manufactured especially for the purpose as they enhance the beauty of the line and color effects offered by the medium.

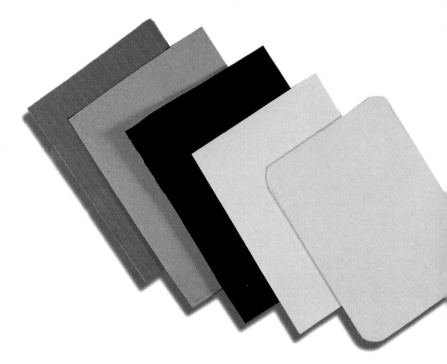

Colored Paper

This is the paper most used for pastels. The most well known manufacturers on the market offer an extensive variety of papers which take all color schemes into account. The best colors to start with are sierra and beige. However, once the enthusiast begins to dominate the technique, more daring colors can be chosen. The color of the paper has a fundamental importance in the development of the picture given that it adds another color to the color scheme of the work and has to be taken into account.

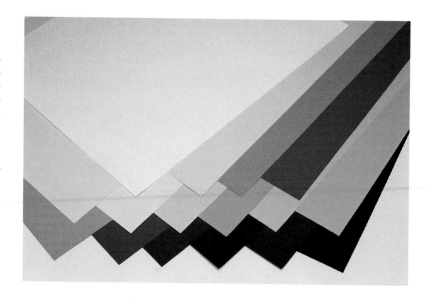

Watercolor Paper

This paper is also suitable for pastels given that it has a high grade of absorption. There are many types of watercolor papers. The most recommendable are those with a certain body and weight.

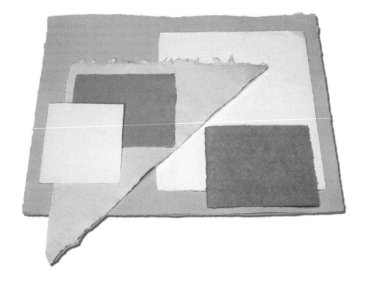

Handmade Paper

This paper has an irregular texture and, therefore, work developed on it acquires particular characteristics. It is not the most suitable paper for a beginner although there is no reason why it cannot be tried now and again. As can be seen in the photograph, the forms of this sort of paper can be caprice and entertaining.

Drawing Paper

A block of drawing paper is a good complement for carrying out color tests and making sketches.

THE GRAIN OF THE PAPER

In a process as direct as painting in pastels, the characteristics of the support are fundamental in the development of the piece and, of course, in its final result. The paper, in addition to its color, is recognizable for the texture of its surface. This texture is established during the manufacturing process when the paper is still in a soft pulp form. If the paper is pressed over a marked surface, this will provide the texture that it adopts. The texture of the paper is also known as its grain.

In general, papers manufactured in an industrial way for the arts have two different textures, one on each side. The smoothest texture is that which allows the line drawn in pastel to stand out the most. On this side, perfect lines can be drawn which are unaffected by the grain of the paper (left). Nevertheless, should we turn the paper over, it can be seen that its texture noticeably varies. On this side, the surface has a deep texture through which the grain of the paper can be appreciated (right). This surface is generally preferred for painting in pastel as it is not only the pastel itself that acts over the paper, but the surface also plays a fundamental role in the development of the lines and patches of color that make up the final piece.

On handmade paper, the grain takes on a special importance when exploited in a suitable way. Pastel can be applied in patches of color and an endless number of effects can be achieved by taking the grain of the paper into account.

SPREADING OUT COLORS

Pastel does not contain a fixer of any form. Once it has been applied to the paper, it is completely vulnerable to being touched and the smallest of rubs can deteriorate its surface. It is precisely this insta-bility that allows the colors to be spread out over the paper.

By spreading out the colors it is possible to achieve a uniform surface from a line or patch of pastel. In this way, the marks made by the application of the material or due to the grain of the paper are elim-inated. There are many ways to spread colors out and, although there are many utensils available for doing this, the most adequate tools, in general, are one's figures.

Paper Spreaders

These are sticks of rolled absorbent paper with firm conical points. They can be used in a variety of ways. The point can be used to draw with, if impregnated in powdered pastel, to diffuse lines or to elimi-nate zones that are not strongly adhered to the paper.

Sponges

These allow particular and precise zones of pastel to be spread out in the picture. They consist of a small sponge fixed to the end of a paintbrush handle by means of a small ring.

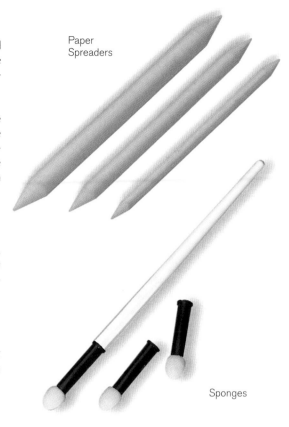

Paper Spreaders

Sponges

Fan-shaped Brushes. These are useful for cleaning areas that may have become dirtied by dust created in the process of drawing lines. They can also be used for spreading out and blending colors.

Brush specifically for spreading out pastel. The brush has a rounded set of hairs and a completely straight profile. It can be used to fulfil many functions from the blending of two zones to manipulating the colors on the paper.

FIXERS

Pastel, as a dry medium with a great purity of color, is particularly unstable and work produced with this technique is especially delicate. As a general rule, pastels should be fixed. There are fixers available in a spray form which, correctly used, allow the pastels, at least during the first stages of the painting, to be strengthened. However, it is important to bear in mind that fixers also bring along some serious inconveniences with them. Consequently, precautions have to be taken when working with them.

Fixers should never be used in the finishing stages of the work. If fixers are applied to finished pieces, the freshness of the pastels will be lost to a darker more compact color. Fixers can be applied at any time during the process, always given that a determined stage has been completed. For example, initial drawing can be fixed once it has been perfectly defined. After fixing, new colors applied will neither change nor mix with those previous used. The fixer should be used at a distance of at least 30 cm away from the work. A light spraying is enough to stabilize the colors on the paper.

When pastel powder is required to spread color over the paper without recurring to a stick of pastel, tools specifically prepared for the purpose can be acquired. However, a small piece of sandpaper with a fine grain can simply be used instead. The piece of sandpaper can also be used to sharpen edges and points.

There are a great many products available on the market that fix pastels. Here, we present no more than a small number of them. The major art ware manufacturers offer very high quality products.

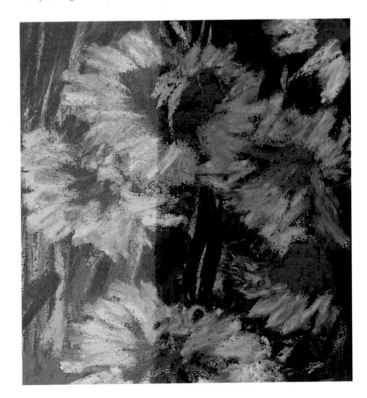

Observe the difference in fixed and unfixed pastel work. In the first case, a freshness and spontaneity of line can be appreciated. In the area that has been fixed, the pastels have solidified and become dull. This is a clear example of the effects of using fixer.

2 Strokes and Patches

Pastel is an artistic medium that can be used in a number of different ways. As can been seen throughout this book, the technique of pastels can be learnt in a progressive way until this medium is dominated.

First Strokes

In this brief exercise, we are going to make our first strokes with pastels. As can be appreciated in the images, the entire surface area of the pastels can be used to draw or paint with and with it not only thin lines can be drawn, but also lines as thick as permitted by the points on even the width or length of the stick. This is the initiation in the technique.

1. It would be absurd to use a pencil or piece of charcoal to lay out a piece to be painted in pastel. The stick of pastel itself can be used to draw over the support without the necessity of recurring to any other drawing device. As the entire surface of a pastel can be used to draw with, similar lines to those achieved with charcoal can be obtained, although pastels offer a greater density. The opaqueness of the colors achieved with pastels allows lines to be covered and for corrections to be made.

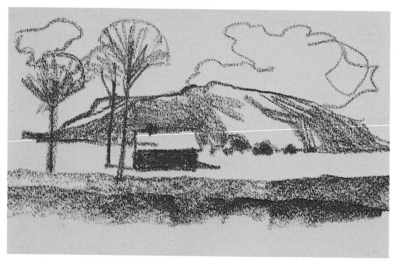

2. If with other artistic mediums the amount of color applied is in relationship to the amount of paint that can be held by the brush used, pastels work in a different way. With this medium, only the stick of pastel is used, on any one of its surfaces, and the paint cannot be extended as if it were a liquid. Works in pastels are developed from lines. These may be closer together or further apart and as wide as the point of the pastel or even as wide as its entire length and as thin as the point of a piece of cloth or the edge of whatever implement used.

THIN AND BROKEN STROKES

Strokes made with pastels can be many and varied. Therefore, it is a good idea for the artist to practice drawing the different lines he or she is going to use in a piece of work before starting. Throughout the exercises proposed, not only can how the strokes are made to draw simple lines be appreciated, but also how they are used to leave marks cut off by a flick of the wrist. In this exercise, the proposal is to paint a flower. Pay special attention to the strokes used in each area.

1. In order to create these first strokes, a pastel on its side offers a great deal of versatility. The strokes that can be made with it, as can be appreciated, are not only straight ones. A pastel from which the protecting paper has been removed can be used to paint with held flat between the figures. Its form facilitates a wide stroke and, as a result, covers each one of the petals without difficulty. Without completely raising the pastel, but giving it a small turn, the thick mark becomes a thinner line as the longitudinal edge of the pastel is used to draw with.

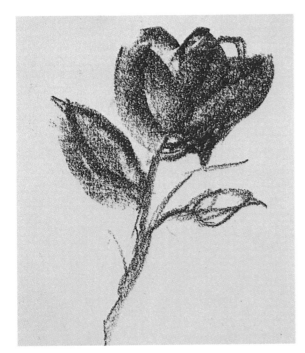

2. When the pastel is placed on its point, the stroke becomes a line of drawing that contains the delicacy that has been transmitted to it through the wrist and figures. As can be appreciated in this photograph, the stalk of the flower and the leaf on the right have been drawn freely without excessive rigor.

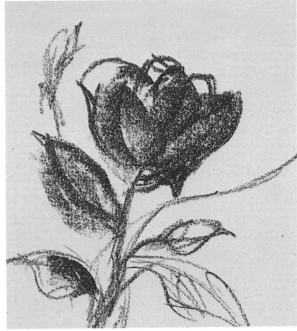

3. The strokes applied with the pastel on its side over the paper can be regulated in intensity and pressure. The texture seen in the stroke not only depends on the corresponding texture of the paper used, but also, to a large extent, on the pressured applied to the pastel. The areas of greater density have been achieved thanks to greater pressure being applied to the pastel in these parts.

DRAWING WITH THE SIDE OF THE PASTEL OR WITH THE POINT

In spite of the fact that lines and marks can be drawn that are very different from one another, the possibilities offered by pastels are governed by the planes of the sticks in which it is presented: the point, which leads to lineal and gestural strokes, or the flat side, with which large areas can be quickly covered. Different possibilities can be practiced in this exercise.

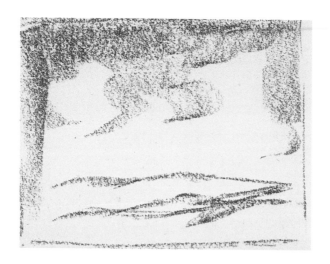

1. In order to create a zone corresponding to the sky, sideways strokes with a piece of pastel on its side between the figures are used. Not too much pressure should be exerted so as not to completely cover the whiteness of the paper. However, the part of this area corresponding to blue should be completely worked whereas the areas of cloud should be left empty. This is called leaving a zone in reserve, as it is the colored area that surrounds the white and reserves the form. The lower part is also worked with the pastel on its side between the figures, but this time the strokes are of an up and down nature. This way of drawing allows the basic layout of the piece to be developed quickly and surely.

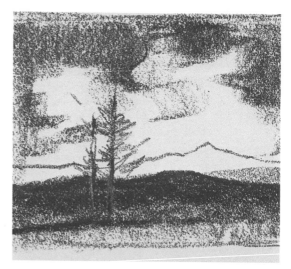

2. This phase of the painting is carried out with the side of the pastel and with strokes moving sideways and, in this way, the landscape is laid out. Now, the piece has a much securer base to work over. In the zones where a greater contrast is required, it is necessary to insist more. However, where a softer tone is asked for, the sides of the pastels should be used, but with the exertion of less pressure.

3. Having completely created the base of the landscape, new interventions to include details can be undertaken. As goes without saying, these latter strokes will be of a much more descriptive and precise nature than the previous ones. They will profile the mountain in the background or the tree in the foreground, for example.

BLENDING COLORS

Pastels are applied directly onto paper. They can be left in this way or blended with one another. When a hand is passed over a painted surface, the colors are spread out and the lines smudged. This section introduces a new concept in this form of painting, one of the resources that is most used in pastels, that of blending colors and tones.

1. The exercise that follows consists in the elaboration of a piece of fruit. Firstly, with a piece of orange pastel, a circle is drawn and the interior painted in cadmium yellow. Over the yellow, orange is painted to divide the piece of fruit into two clearly differentiated zones. Without applying more pressure than necessary so as not to mix the colors, the zone on the right is rubbed with the figures until a uniformed tone is achieved.

Upon arriving at the area that unites the two colors, soft rubbing is carried out with figures until the zones are blended together.

2. This is a particularly interesting point as here, we can see that the blending of one color over another does not necessarily have to extend over the complete area occupied by the first. It is sufficient to rub with a figure in one of the zones without touching another.

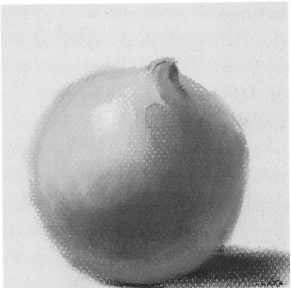

3. Use orange again for the zone that corresponds to the shade and diffuse the lines: more softly in the lower part and in a rougher way in the area where greater light would be found. Finally, paint in the shadow cast.

The Language of Pastel

Still Life

Materials required

Colored paper (1), pastels (2) and a cloth (3).

Pastel is an ideal medium to translate into a pictorial language what, to begin with, may be nothing more than a few marks of drawing. In this exercise, a first intervention with pastel is proposed. It is not necessary for the result to be identical to that shown in the images. This can be achieved later with practice.

When painting with pastel, remember to be very careful with anything that could rub against the work produced.

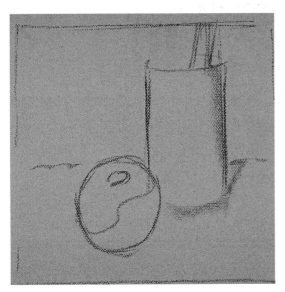

 1

The side of a pastel can be used as much as its point. The result obtained being different according to how the material has been applied and it is a question of making the most out of each sort of mark made on the paper. With the pastel on its side over the page, straight lines of great precision can be drawn. This technique can be used for drawing the sides of glasses.

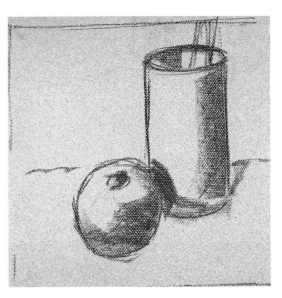

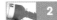 **2**

It is simpler and often more precise to work with a small piece of pastel than with a complete stick. Break the stick and start drawing with it on its side over the page using strokes that run from left to right. Do not apply too much pressure so as not to fill in the grain of the paper.

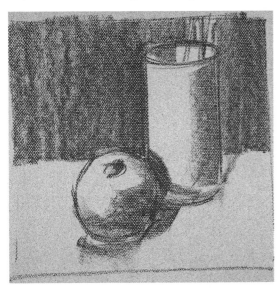

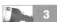 **3**

All of the background is painted with the pastel flat on its side and with regular strokes. As can be tried and tested, pastels can be used to obtain all sorts of different marks on a piece of paper. Observe, for example, the nature of the strokes used in the apple. In the darker zones, more pressure has been applied.

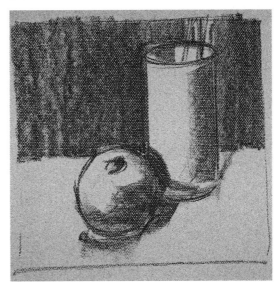

 4

In this detail, it can been seen how the background has been drawn with a similar amount of pressure to that applied when drawing the side of the glass. Up until now, the two tones are identical. In the next step, the effect that can be produced when two strokes are superimposed will be appreciated.

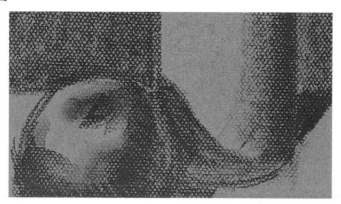

 5

With a small piece of pastel, on its side, draw a vertical line to the right of the glass: in this way, the shadow is intensified and the sensation of volume augmented. The dark interior of the recipient, on the other hand, is painted with the point of the pastel which allows the form to be well defined and at the same time be considerably darkened.

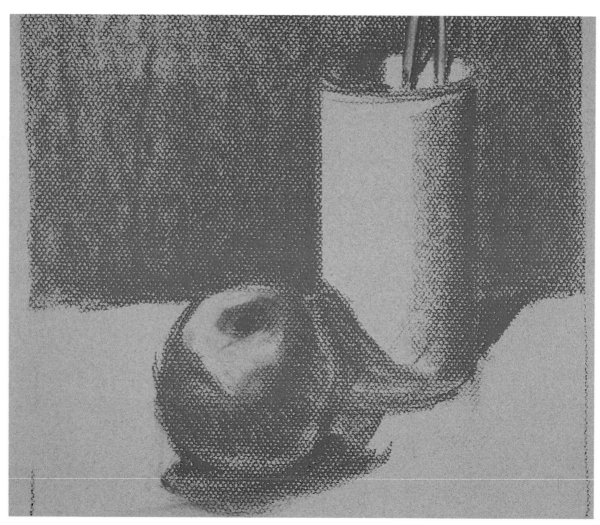

 6

To conclude the exercise, the background is darkened with strokes using the pastel on its side over the paper. By darkening these areas, a strong contrast with the lighter tones of the areas that have not been painted is achieved.

Strokes made from left to right with the pastel on its side allow thick lines with homogeneous textures to be drawn.

Strokes made with the pastel on its side and in a longitudinal sense allow firm straight lines to be drawn.

Strokes made with the point of the pastel lead to gestural lines, as has been seen in the profile of the apple.

By superimposing one stroke over another, the pore of the paper can be covered.

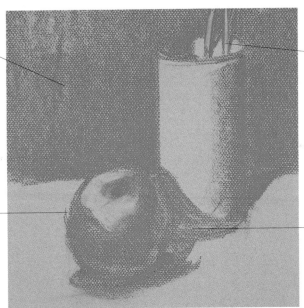

Genius

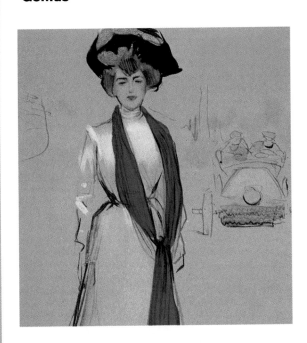

Genius often lies in knowing how to make the most of what is offered by a medium, pastel in this case. This painting, La Musa of Montmartre by Ramón Casas (1866-1932), hardly contains color. However, the talented painter knew how to describe the complete volume and contrast of this woman's dress in no more than a few strokes. How? He found it enough to use a simple diffusing of white pastel to include the color of the paper in the painting.

3 The Initial Sketch

As will be seen, the possession of a solid knowledge of drawing is very useful when it comes to undertaking any work in pastels. In this technique, as in any other, the success of our work is determined, to a great extent, by the quality of the initial sketch.

Drawing with Pastels

Given the qualities of this medium, and that the treatment of the drawing should be fresh and spontaneous, it is a good idea to dedicate as much time as necessary to acquire looseness and confidence. If you have a certain experience in the field of art, you will see that the way of holding the pastels and applying them to paper is very similar to the techniques used for drawing with charcoal or graphite sticks. As any part of a pastel can be used to draw with, the strokes that can be produced depend on how it is placed over the paper. It is neither necessary nor advisable to apply excessive pressure to the pastel when drawing as it is a soft medium and excessive pressure will ruin the work and probably lead to the pastel stick breaking.

Composition

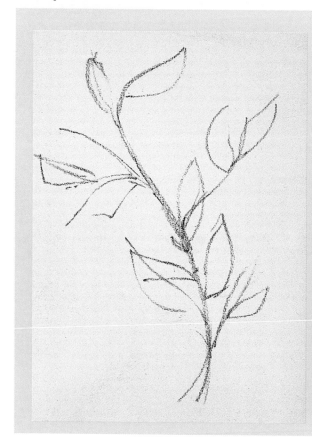

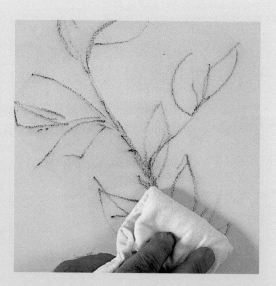

The initial phase of the work consists in laying out the overall design of the piece as loosely as possible and without entering into too many details. Observe how the line drawn varies in thickness depending on how the pastel has been placed over the paper.
The instability of the medium allows the lines to be rubbed out with a simple cotton cloth. As a result, correcting or eliminating parts of the drawing become very simple tasks.

THE PROCESS OF PAINTING IN PASTELS

In the technique of pastels, the figures are defined in a progressive way. On the previous page, we have seen how an initial sketch of the stalk that we have taken as a model has been made. In the following, we will see how a variety of subjects can be defined in a quick and convincing manner from no more than a small number of lines.

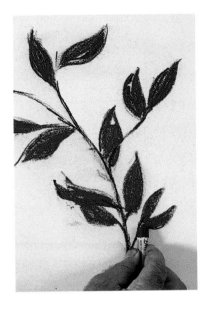

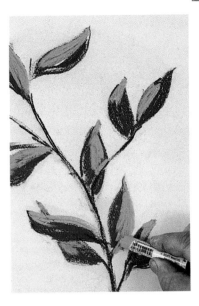

1. Firstly, with dark green pastel, draw all of the leaves. This operation is carried out with the point of the pastel and by insisting more in determined parts of the stroke and leaving some interstices through which the paper can breathe.

2. The opaqueness of the medium allows lighter colors to be superimposed over darker ones. This is what has been done in the following: the more luminous parts of each leaf have been painted in a light shade of green.

Although it can be a tempting device, blending should not be abused of or overused. We advise that it is only applied to determined zones of the picture to avoid the work becoming overloaded.

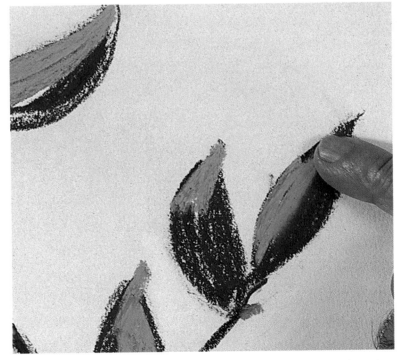

3. In this detail, the freshness and immediacy that characterize works in pastels can be appreciated. It is enough to pass one's figure over the line that separates the colors used to blend them together and for their gestural aspect to take on a finer and more elaborated character.

THE SCHEME

Before starting to paint, and so that the piece may come to a successful conclusion, it is of utmost importance that the initial scheme is suitably consolidated and the overall composition established. The simplest subject matter, which could easily be derived in banal composition that lack interest, acquire great relevance if this phase of the work has been resolved adequately. Taking into account the composition also helps center the piece on the paper.

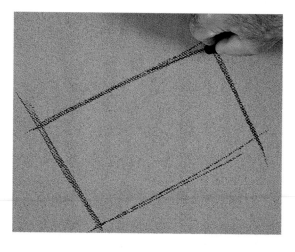

1. Firstly, once having decided how to arrange the elements, we go on to embody them in a simple geometric figure – a rectangle in this case – and try to see the whole as if it were one object.

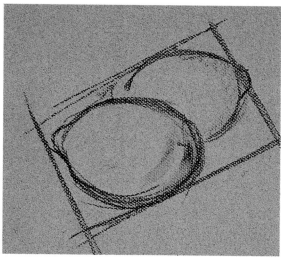

2. In the interior of the rectangle, which we have just drawn, we draw the two lemons while taking into account the proportions and profile of the whole. Observe how the figures arranged in this way fill the entire area left for the purpose.

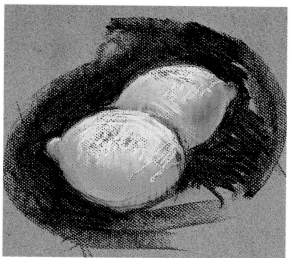

3. Now, paint the lemons and rub out, if it is necessary, the lines used to position the subject. In our case, when it comes to painting on top of them in pastel of the same tone, they become perfectly hidden.

THE COMPOSITION

Symmetrical objects, such as the teapot that we take as a model in the following exercise, may be the most difficult to resolve. This is because a very evident deformation of the object is produced in the smallest deviation of the line. In order to facilitate the development of these themes, it is necessary to compose with precision and reduce the subject to the basic geometric forms of which it is made up. The more complex forms can be added and progressively elaborated later.

1. In order to start, the teapot is centered on the page by means of the square. The flower in the foreground, not needing to be so highly defined, has been simplified with a circle and lineal stroke corresponding to its stalk.

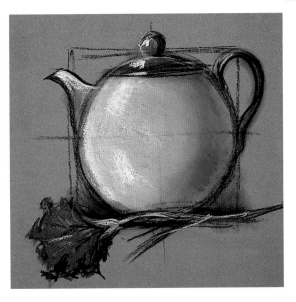

2. Draw the axis of the picture and circumscribe the circle that the teapot will occupy over it. The vertical axis allows the center of the lid and the base of the teapot to be established while the horizontal axis helps situate the handle and spout.

3. As can be seen here, the detailed structuring and precise scheme have led to the correct formal development of the teapot. The flower, on the other hand, has been resolved with a few loose strokes in bright red.

Painting on Canvas

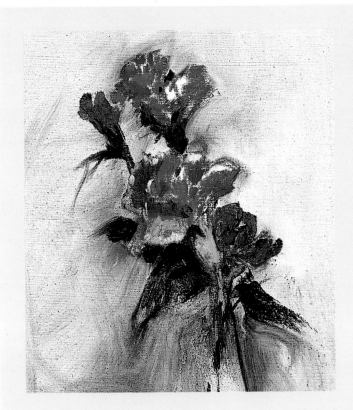

Although the most suitable surface for painting with pastels is paper, many artists use canvas. Any type of pastels can be used to paint on canvas although oil pastels are the most recommendable. These pastels adhere to the canvas with strength and can be worked with turpentine and paintbrushes as well as being mixed with oil paints.

SUPPORTS AND TEXTURES

Given that a drawing in pastel is made up of particles of dust, it is indispensable that the support offers a minimum of roughness that "scratches" the pastels so that the pigments stick to it. In addition to the papers especially manufactured for pastels, artists have other adequate materials available to them such as conglomerates for pastel or sandpaper.

There are, in fact, very few supports that cannot be used with pastels. In particular cases, cardboard from packing boxes, old newspapers and other rough surfaces such as felt can be perfectly valid. Do not hesitate to carry out experiments.

Fine-grained industrial sandpaper is a very popular support among those who draw with pastels. It is quite economic and offers an abrasive surface which holds the colors well. Some manufacturers produce a large-sized sandpaper especially for drawing on.

Conglomerate for pastels, better known by its brand name, is made up of particles of cork. These create a surface which is a little smoother than that of sandpaper, of a light brown color and which allows pastels to adhere to it well without any textures from the support being noticeable.

Broad-grained watercolor paper is also particularly suitable for pastels. The final result offers a pronounced grain and has the added advantage that it is possible to previously color the paper with a wash of a desired tone.

PRACTICE ON VARIOUS PAPERS

The surface to be painted does not have to be white. For this reason, paper manufacturers offer an extensive range of colors. In day to day practice, the color of the paper is chosen by the artist so as to combine well with the colors of the pastels that he or she is going to use. Here, we propose a simple exercise on three different sorts of papers. Due to the chromatic variations, we will be able to appreciate how pastel responds to being used on colored backgrounds.

FINE-GRAINED PAPER

The back of granulated papers always offers a surface with a finer grain. This is adequate for those cases when we do not want a surface texture to stand out. Pastels tend to cover areas more densely when used on fine-grained papers. For this reason, although the exercise has been carried out on a colored paper, this background color can only be seen in the zones in which we want it to predominate.

Landscapes are particularly suitable for experimentation. All sorts of different techniques from blending tones to highly defined lines can be used in them.

1. In order to do this exercise, juxtapose three papers of different colors: blue, red and ochre. Sketch a landscape with a dark pastel and, to follow, paint the upper part of the sky in blue.

2. Without applying too much pressure over the pastel, paint the clouds white. Observe how the grain of the paper does not become completely covered and how the color of the support can still be seen through the strokes of pastel.

3. To continue, paint the ground in red and yellow tones and add three trees that give the sensation of verticality to the scene. As can be seen, the tones of each piece of paper influence the overall color scheme of the picture in different ways.

Drawing

Monochrome Still Life

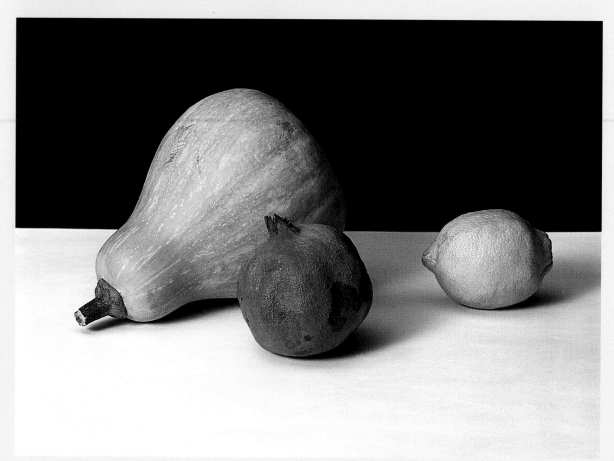

Materials required

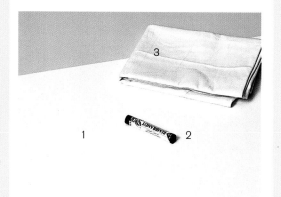

Medium-grained white paper (1), a pastel (2) and a cotton cloth (3).

Pastel is not only one of the most complete artistic mediums that exist, but it is also a technique very close to drawing. In fact, some authors consider it to be this, drawing. As any part of the surface of a pastel can be used to draw with, a great number of different sorts of strokes can be created and, thus, great expressiveness given to the work. In this exercise, these possibilities are going to be developed with just one color. Special attention is also going to be paid to studying the composition of a still life. Do not scorn compositions based on simple forms, as these help us to understand and create others that are more complex and elaborated.

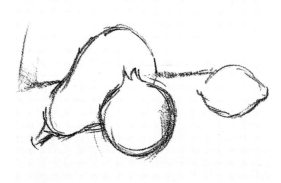

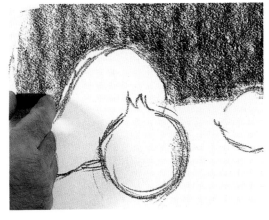

As previously commented upon, in order to avoid a lack of interest in simple compositions, it is necessary to study the composition with great attention to find a good presentation of the elements used. In this case, the pieces of fruit that have been drawn are situated within a rhomboid scheme.

With the pastel on its side between the figures, cover the background with vertical strokes and delimit the form of the pumpkin. The background will be progressively darkened to suggest a greater contrast.

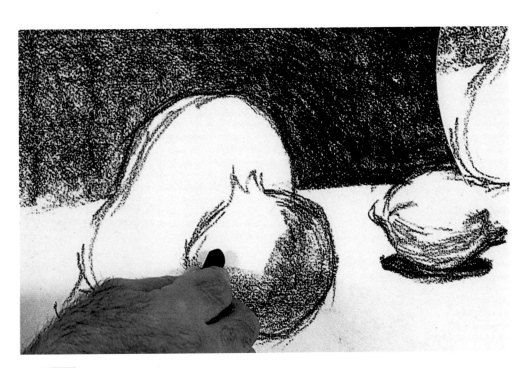

Start to define the volumes of the pieces of fruit by drawing the shadows of the lemon and the pomegranate. Notice how the point of the pastel has been used in the first case while, in order to fill in the shading of the pomegranate, the pastel has been placed on its side and given a light turn so that it can be adapted to the line of the drawing.

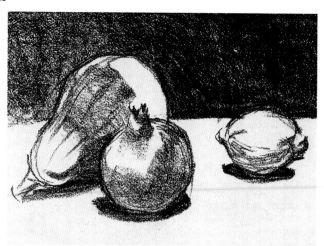

The pumpkin has also been established with the pastel on its side. Later, with the point, the characteristic furrows of this vegetable are drawn. Gradually, the details of the pomegranate and the shadows cast over the table are included.

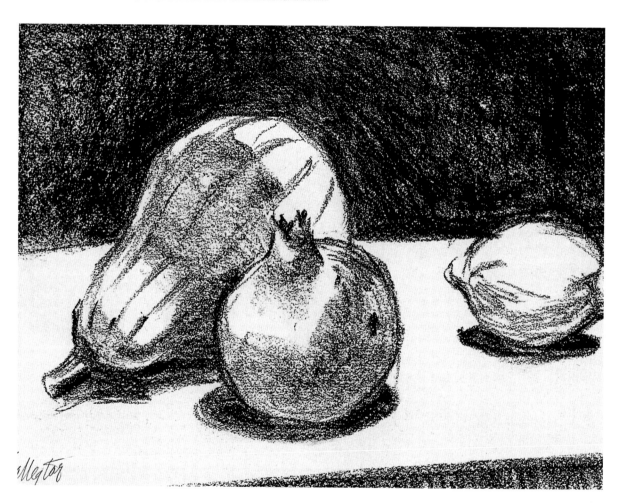

Lastly, the contrast is intensified by adding successive coats of pastel over the darker areas. As you will have noticed, pastels are a medium as adequate as charcoal for chiaroscuro studies.

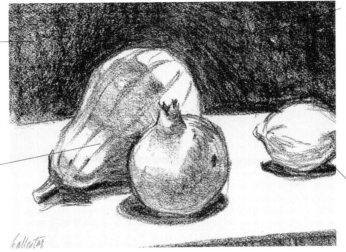

The background has firstly been covered with vertical strokes using the pastel on its side and without exerting too much pressure so that the paper can still be seen.

Combining strokes using the pastel on its side with others made with the point multiplies the expressive possibilities of pastels.

Over the initial background, the superimposition of strokes has allowed us to create a tonal graduation that increments the depth of the scene.

The lineal strokes with the point of the pastel are the most adequate for representing the rough texture of the lemon.

El Maestro of Light

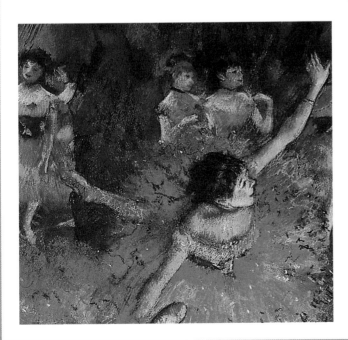

Degas had a special preference for the theme of dancers and the world of the theater. This was for two reasons: he could study the different effects of artificial illumination and also capture the instance as if his picture were a photograph. It is interesting to study the work of Degas, one of the best pastel painters in history, so as to appreciate his way of understanding light and form through color in works that are pure and direct.

The lights create strong contrasts. However, we cannot talk about chiaroscuro, as there is no transition in the tones. This characteristic of his painting is strengthened with the pastel technique that allowed him to work directly and in which light tones can be superimposed over other darker ones.

4 Color Schemes

It is an authentic delight for any pastel enthusiast to open a box containing some 200 different colors and see the enormous variety and purity of colors offered by this medium. Although, of course, it is not necessary to acquire such extensive selections: 20 to 30 sticks of pastels are sufficient to start with.

The Color Schemes

The ranges of colors and their names vary according to the manufacturer. Therefore, it is more advisable to allow yourself to be guided by sight rather than by references. There is no reason why pastels of different brands cannot be mixed. They are all compatible with one another.

Colors are, of course, classified by families (earth tones, for example) or by temperatures (cold colors and warm colors). Pastels are also presented grouped in such a way so as to ease finding the different colors and the execution of works that present a particular dominance of determined tones.

There are boxes that contain exclusively the colors required to paint a landscape and exclude those tones that are not present in nature. Boxes of pastels for portraiture in which flesh tones predominate are also available. Before the pastels deteriorate to the extent that their wrappings cannot be read, draw up a color chart and note the reference of each one of the pastels in case any need to be replaced.

Colors that make up the color ranges maintain a certain harmony amongst themselves. These harmonies may consist in the combination of similar colors or in those that belong to the same family. This is the case of earth colors that include a great variety of tones and luminosities. Another very simple way of creating a harmonious scheme is by using complementary colors which are those that lie adjacent to one another in the color circle.

In this way, tones that contain, in smaller or greater amounts, the same color base are combined. This would be the case of a scheme based on yellow, yellowy orange, orange and orangy red.

THE COLOR CIRCLE

The color circle represents the relationships among the colors of the spectrum in a clear and graphic way and gives us a good idea of what the results of certain mixtures will be. It is divided into twelve equal sectors in which the primary colors yellow, magenta and cyan are found.

Between these primary colors there are secondary colors: red obtained from mixing yellow and magenta; green, from yellow and cyan; and violet, obtained with magenta and cyan.

A further division includes tertiary colors which are obtained by mixing a primary color with an adjacent secondary color on the color circle. For example, by mixing magenta with violet, we get purple.

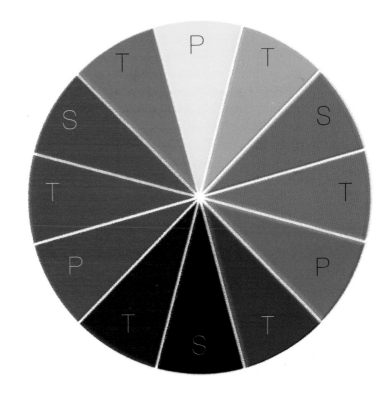

Colors that lie opposite one another on the color circle are referred to as complementary colors. In this way, yellow, a primary color, has as its complementary color, violet, the secondary color obtained by the fusion of the other two primaries.

The sum of all of the colors of the spectrum is white light. However, when a pigment is mixed with its complementary color on paper, a gray tone is produced. A bluish tone, for example, turns gray when orange is added.

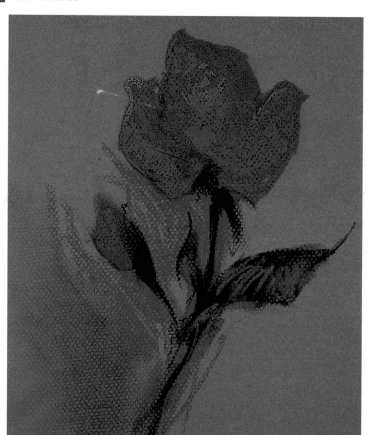

THE WARM RANGE

The classification of colors as being warm or cold responds to an appreciation that is somewhat relative. However, it does have an importance when it comes to learning how to use our palette. Although each range corresponds to particular themes, it is always important to bear in mind the other colors that are to be used. For example, purple will appear colder combined with red than combined with blue. In the first case, the bluish component will stand out whereas, in the second, the reddish. In this exercise, the objective is to practice with different colors from the warm range.

The combination of opposite colors from the color circle allows a very pronounced contrast to be obtained which, in appearance, augments the intensity of each one of them. In this example, it can be seen how pink stands out on the blue paper.

Should you wish to strengthen the colors and give force and contrast to the drawing, use a paper of a complementary color to the color used in the drawing. Pastel is a medium particularly suitable for this sort of visual effect.

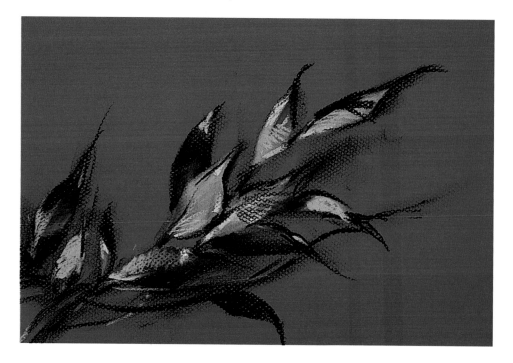

1. The color of the paper used has a decisive influence over the colors that are painted on top. The preliminary laying out can be undertaken in any color. It does not really matter if it is lighter or darker than those that are to be applied afterwards. This is because the opaqueness of the pastel allows for one color to be superimposed over another and the initial lines will become perfectly covered by the colors that are added later.

2. The first colors are applied. These are used to block in the sky in the background. This phase is carried out with the pastel on its side between the figures. The amount of pressure applied over the pastel will determine whether the pore of the paper is closed or left open. The colors used in this exercise all belong to the warm range. Over the colored base, in the lower part of the sky, a reddish tone is applied which is blended in with the color below.

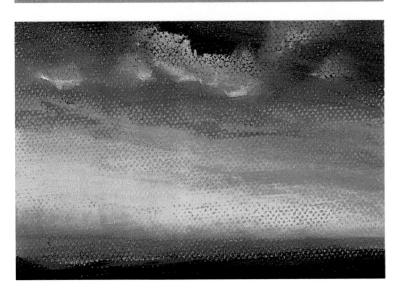

3. In very luminous yellow tones, the clouds are painted. This is not a complicated process, but it should be carried out with delicacy as the luminous color has to be completely mixed over the background. Once they have been blocked in, the masses of the clouds are softly extended with the figures and the color is integrated over the background. Over this luminous color, another much lighter one is painted. This new addition is to highlight the lighter parts of the clouds and this time, the tones are not blended with those that lie below.

THE COLD RANGE

In the proposal presented on this page, the colors that are to be used are some that correspond to the cold range. Blues, greens and some yellows belong to this range of colors. As in the previous exercise, this proposal has no other objective than that of showing how a particular color range may be applied.

1. A horizontal line is drawn high on the page as the subject to be developed occupies an area that corresponds to water. This simple stroke on the horizon marks the beginning of a sequence of colors. It starts with a dark blue tone, always in horizontal strokes, continues in a medium blue and finishes in an emerald green. None of the colors have as yet been blended and the paper can still been seen in some zones.

2. The tones that have been applied are softly blended together. The limits between the colors almost completely disappear and the characteristics of the strokes themselves disappear in a tenuous fusion of colors mixed over the background. It is not necessary to apply a lot of pressure with the figures in order to blend the colors. The effect can be achieved with the lightest of pressure and care should be taken not to close the pore of the paper by applying excessive pressure.

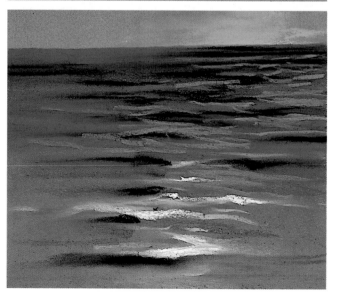

3. Over the previously established tones, other lighter ones that represent the more luminous parts of the seascape are drawn. Darker colors that contrast as much with the background as with the lighter strokes are also used. These last details are the ones that determine the luminosity and texture of the surface. The highlights are much more precise and consist of very much lighter and luminous tones than those used in the color sequence.

1. The elements of a landscape are sketched in with a black pastel given that at this stage, the priorities between background and subject are to be established. As can be seen, the tree in the foreground stands out perfectly from the other elements of the composition.

2. The principal planes have to be separated in order to establish the depth of the scene and position of each of the elements. Firstly, the sky, the most distant plane is painted. This area is not painted in just one color, but in a number of tonal variations.

3. The colors of the background are blended together with the figures. The tones of these colors unify to produce an interesting mass of light and dark. Notice how the plain color of the paper varies according to the tone that is used on it. In the zones in which the sky is white, the green of the paper becomes darker due to the effects of the contrast. On the other hand, in the zones in which the blue is darker, the contrast with respect to the green seems to be much more balanced.

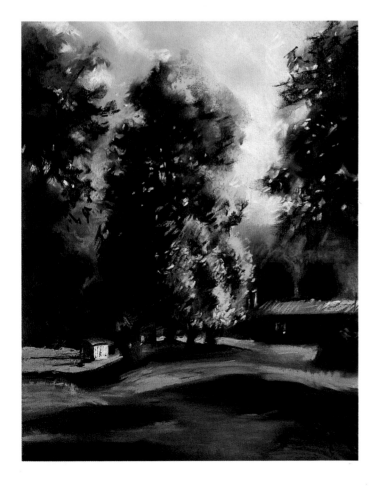

4. When working in the pastels, the idea of mixing before painting does not exist as each color is applied as it comes from the box. Although some of the colors used in this exercise may not figure among the range of pastels possessed by many enthusiasts, this does not matter as any similar color can be used. With a light green, the luminous areas of the lawn are drawn and the shadows in the foreground are painted in dark blues and grays. Lastly, the touches of luminosity in the tree in the foreground are applied by striking the pastel against the paper. In this way, the entire tree is integrated into the background of sky.

Color Schemes
Landscapes

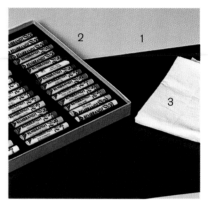

Tobacco colored paper (1), pastels (2) and a cloth (3).

Landscape painting is a very interesting theme when it comes to developing different color schemes. The one dealt with in the following exercise possesses a great variety of shading made up of a range of cold colors. In this model, innumerable touches of blues and whites can be appreciated. Although the process may seem to be complex, a positive result will be obtained, if the images and technical explanations are followed with attention.

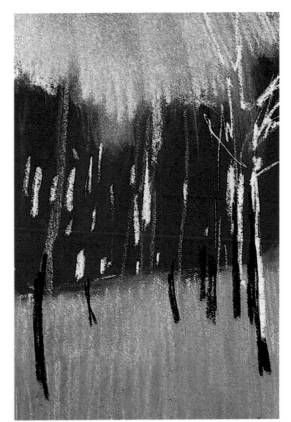

The initial layout is established in a very light color that stands out strongly over the background. Do not attempt to draw all of the trees as this would be more than impossible. Only sketch in a few vertical lines that lead to an understanding of the composition. The lower area that corresponds to the ground is painted in white and blue using energetic vertical strokes which form two clearly defined bands.

2. In a whitish bone-colored tone, the upper area is drawn with vertical strokes. This corresponds to the visible part of the sky above the tops of the bare trees. As much the upper part as the lower part is blended with the figures and, for the moment, the strokes loose their presence. In black pastel, the first shadows of some of the trees and, with direct strokes in a bone color, openings in the background are drawn. The brightest areas are painted with white strokes.

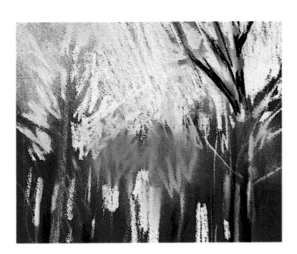

3. More bone-colored strokes are added to the upper part of the landscape. This time, in a much more direct way and some of the branches of the trees are left unpainted, which is to say, in reserve. The background is painted in an earthy green and the colors are lightly blended together with a figure. We also tone down the excessive whiteness of the trees.

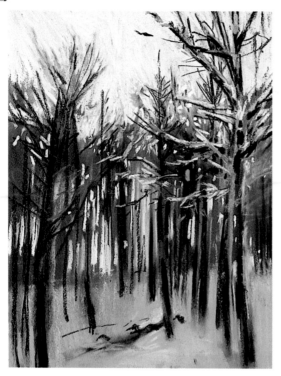

4

The profusion of bone-colored strokes in the sky leaves unpainted areas of the background on view which intermix with the trees painted in the foreground. In order for the appearance of the trunks to be credible, it is necessary to paint some intense contrasts in black. This is a very important step.

The intervention of the cold colors is directly over the ground and the strokes are superimposed over the previously blended background. If the part corresponding to the branches is studied closely, it can be seen that the branches have been superimposed over this blended background with new strokes.

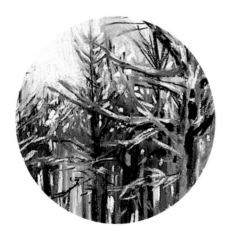

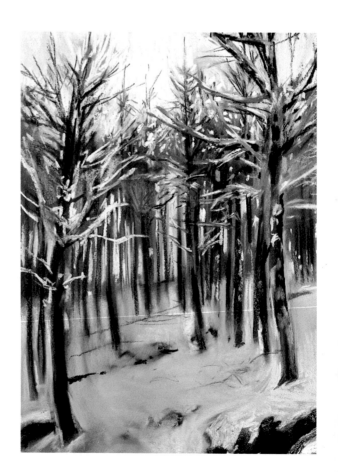

5

The conclusion of this exercise is quite elaborate. The details of the trees in the foreground are superimposed over those lie further back. It is precisely at this point where the differences in contrast allow the form to stand out. The brightest points corresponding to the snow on the branches is painted in pure white while, in contrast, the dry part of the tree has been painted in black and gray. These tones help the luminosity of the snow stand out even more. Lastly, with a few touches in blue, the more distant trees are finally established.

The initial layout is carried out in a very light color that clearly stands out over the background.

The area that corresponds to the visible part of the sky over the branches of the trees is painted in a bone color using vertical strokes.

The brightest points corresponding to the snow on the branches are painted in pure white.

The background is painted in an earthy green and the colors are blended with the figures.

The lower area is painted in white and blue that is blended together with the figures.

Black is used to strengthen the tree trunks and contrast the less illuminated areas.

Pastel and Impressionism

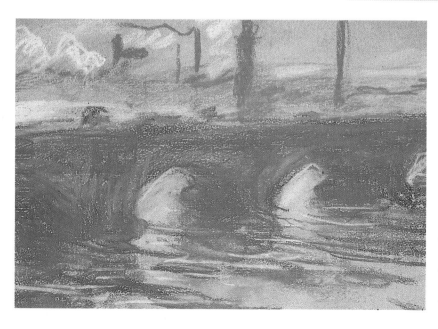

Monet was one of the principal impressionist painters. He is considered to have been the principal forerunner of the movement, the name of which comes from his work Impression: Sunrise (1872). The theories of impressionism were developed by Monet all through his career: the understanding of light, the impacts of color and so on. His work influenced artists of his generation and continues to be a point of reference for many painters today.

5 Layout and Painting

In order to paint a picture well, it is essential to start with a clear initial layout. In this section, the importance of the construction of the model is going to be given particular importance.

It is very important to learn the complete process that is indicated in the following. If this is assimilated into a working routine, the complete development of the picture will be much easier and the final result will be more satisfying.

Beginning a Lineal Layout

The general layout of a picture is established with no more than the lines that are indispensable to establish the principal structure. For example, if you are planning to paint a bunch of flowers, the first lines do not deal with the details, but with the relationship the bunch of flowers has with its surroundings, the positioning of the most important elements and establishing the areas of light and shade. The first lines are no more than a basis for the much more elaborated work that comes later.

1. Any enthusiast can produce a scheme as simple as this one without any difficulties. The figure represented in the photograph is no more than a frame within which the different elements of the bunch of flowers is to be placed and later developed in complete detail.

2. When the basic structure of the picture is completely established, the final result of a drawing is much more precise. This working process will help the artist understand any model no matter how complex it may seem to be. As the enthusiast acquires experience that comes from practice, he or she can begin to skip these preparatory steps.

PAINTING, AN APPROACH TO COLOR

Once the layout has been resolved on the paper, painting the picture begins. Firstly, the supplementary lines that have been used to construct the still life should be eliminated. Depending on how the picture is worked, these lines can be rubbed out or covered with new colors. Once the first part of the process has been completely concluded, it can be consolidated with fixer. However, it should not be forgotten that what is fixed can no longer be rubbed out.

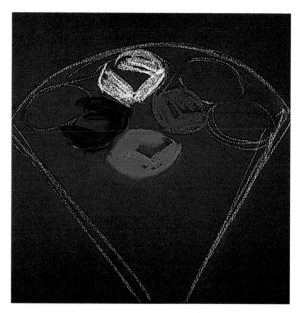

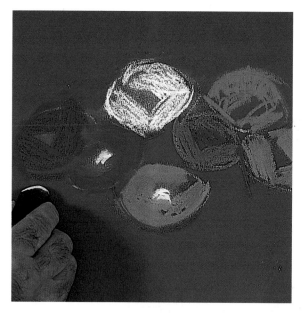

1. The first colors of the flowers are established with the pastel on its side between the figures. The background integrates perfectly as another color in the composition.

2. The pastel can be blended or left as it has been applied. Both of these resources have to be very well controlled as of the beginning of painting the picture. The areas that are to be blended can be given firm strokes. Over the first areas painted, new lines that define the contrasts can be drawn. With a rubber, the marks that fall outside the outline of the flowers can be eliminated.

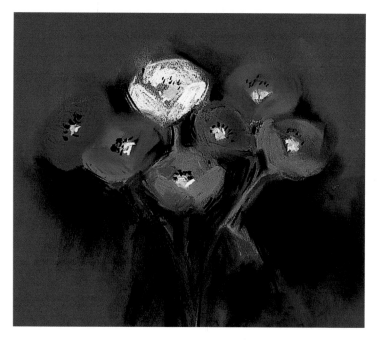

3. Given that it is difficult for an artist to be in possession of all of the colors on the market, a practical and well-used resource is to use black pastel to obtain some tones of the colors. Take note of the large variety of tones that can be obtained by adding some black here. Bear in mind that blending this color over those below leads to a loss in the quality of the strokes made.

THE BRILLIANCE OF COLOR, THE ABSENCE OF MIXING

Unlike wet techniques, in which the colors are obtained by means of mixing on a palette, the colors available to those painting in pastels are limited to the contents of his or her box. As has preciously been mentioned, in order to avoid the risk of ruining the colors and overloading the paper with pastel, it is recommendable to use colors from the extensive selection available rather than mixing them yourself. There are also numerous resources for adding details and for breaking up the monotony of the color.

1. When working in pastels, more than in any other medium, the shade of the color is of fundamental interest. This is a simple exercise in which the importance of the different tones of pastel and how mixing is not necessary to obtain different shades can be appreciated. Firstly, paint in the color that will serve as the base. In this first covering, grade the tones in three stages.

2. Softy rub your figures over the base of tones drawn on the colored paper in order to blend them together. This blending is not to mix the colors together, but simply to establish a tonal base over which strokes and details can later be developed. When blending, take care of the integrity of the color in such a way that it only alters the margins of each zone.

3. The previously established colored base allows new tones to be added. This time with the point of the pastel so as to allow direct strokes to be superimposed over the earlier graded coloring. This effect is one of the most interesting that can be developed with pastels. The strokes that are added to the picture are applied in a direct way and, as can be seen in the example, a variety of tones are used with the objective of making the different planes stand out.

PROCEDURES FOR NOT DIRTYING THE PICTURE.

Pastel is a medium that can be easily altered with a figure. This is a great advantage, but, at the same time, it also represents an inconvenience: the picture can be smudged accidentally.

In the first phases of painting the picture, this may not be of great importance, but, as the painting advances, any accident can destroy hours of work. This can be avoided by applying a variety of very simple measures.

When painting with pastel, it seems to be inevitable to smudge the painting with the movements of the hand. The effect is incremented above all when a painting elaborated with a large number of different colors is concerned. However, this situation can easily be avoided by protecting the worked area with a piece of paper.

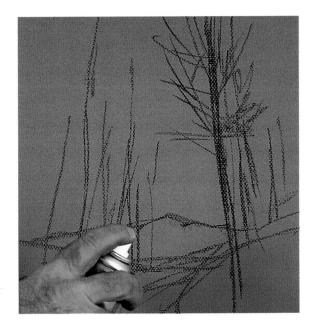

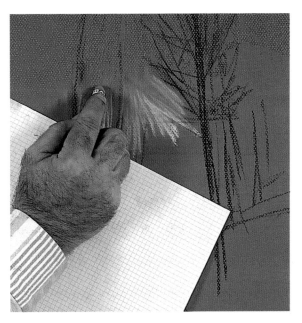

One of the surest and most habitual ways of conserving your work is to fix the pastel at an early stage in the elaboration of the picture. With a light spraying, the smudging of the first layers of color by a hand or other pastels passing over them can be avoided. Nevertheless, this procedure should only be used during the first stages of the painting process.

Thanks to the use of a piece of clean paper placed under the hand, it is possible to work without smudging areas already painted. However, it should be taken into account that the piece of paper should not be moved over the painting and that it should be changed for a clean piece with certain regularity. With this simple procedure, undesired smudging of the painting can be avoided.

Layout

A vase of flowers based on simple forms

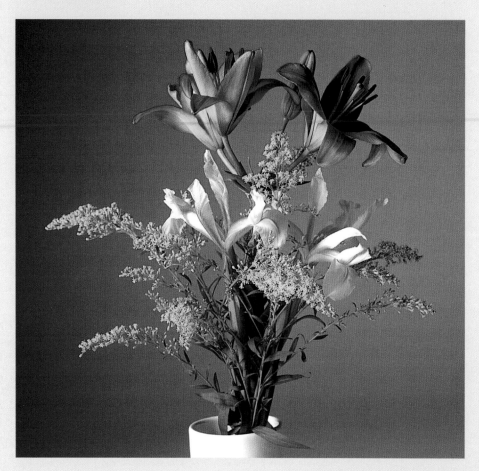

Materials required

Gray paper (1), pastels (2) and a cotton cloth (3).

Whatever the artistic technique in question, the layout is always fundamental. It is curious to think that with no more than a few simple lines that an ideal structure can be achieved for the most elaborate work of art.

Working in pastels facilitates the progression of the painting. As with the application of color, the layout can be corrected as the work is developed. In this exercise, we will paint some flowers arranged in a simple layout.

A special virtuosity is not required to elaborate a simple layout. A few well-interrelated strokes that make up simple geometric forms are sufficient. A much more precise construction can be developed over these elemental figures. With the same pastel used in the first stage, the layout is elaborated further. The forms are defined more easily thanks to the strokes from the first scheme serving as a guide for other more concise lines. As the opaqueness of the pastels allows everything to be continually reestablished, an exact drawing is not necessary.

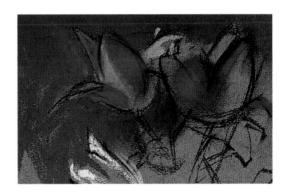

The background is painted in gray, the higher forms of the flowers are established and the lines of the initial layout are covered. Start to paint the higher flowers: the darker petals in orange and the lighter ones in a very luminous tone. The most brilliant tones in the flowers in the center of the composition are established in white without completely covering the background.

In gray and blue, finish painting the background and start blending the strokes together with your figures. Continue painting the flowers in the higher part in orange and leave some zones in reserve through which the color of the paper can be appreciated. Apply a series of small impacts over the paper in yellow pastel to begin to establish the textures for the small flowers. Use two different yellows. The stalks of the flowers are sketched in black over which diverse tones of green are painted.

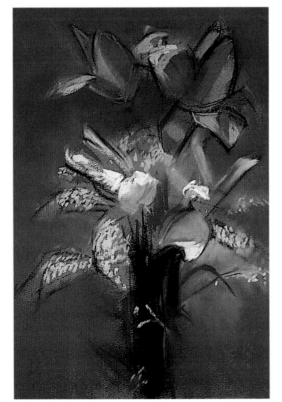

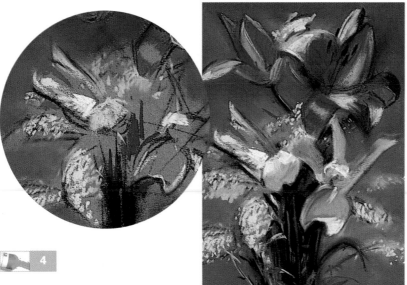

5

Over the tones used to paint in the higher flowers, new strokes are created that combine different colors which are not blended into one another. The highlights are applied in a direct manner without an intervention from our figures.

4

Finish off the background by blending in new tones of gray. All of this area is unified with the figures without interfering with the flowers. Over the yellows previously blended over the background, successive touches of color are now added. The white flowers are also softly blended in, but without completely eliminating the presence of the color of the paper.

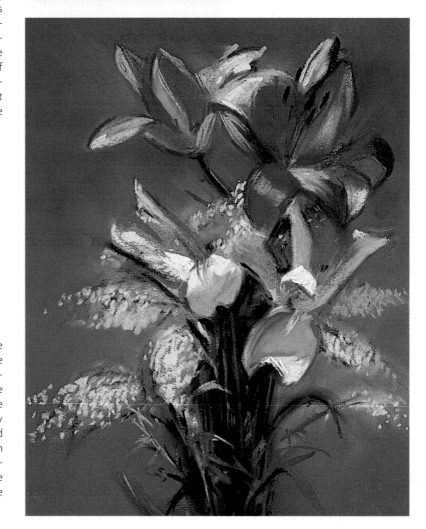

6

Finish off painting the stalks of the flowers in a large variety of greens. The dark parts in this area provide a perfect base over which the depth of the shadows can be represented. The white flowers are finally profiled by the tones and colors that surround them. Lastly, the numerous impacts in yellow are completed and mixed together with those previously made and with the blended tones of the background.

The initial scheme is completely geometric. In this way, the overall composition can be created without going into details.

The higher flowers were stated in a very general way. Initially, they were created with no more than two colors.

The white flowers are profiled by the tones that surround them.

Paint over the initial black of the stalks in luminous greens.

Blending and Contrasts

Odilon Redon played a very important role in the artistic avant-garde and his influence over later painters is more than evident. Initially, along with Gustave Moureau he followed the symbolist trend which, later, flowed into surrealism head by, among others, Salvador Dalí.

Due to the way in which pastels can be blended along with the contrasts facilitated by impacts of color, it was surely Odilon Redon's favored technique. In fact, a large part of his work was carried out in pastel. The realist character of the picture is complemented with annotations that have been no more than insinuated. On the other hand, the way in which the color of the paper has been integrated into the overall composition is also of particular importance.

6 Contrast and Color

The unusual floury consistency of pastel due to its lack of a glutinous substance has various consequences. On one hand, it leads to work being easily dirtied, but, on the other, it allows lines to be blended together or toned down so that the limits between colors even vanish which, in certain cases, can be very useful.

Blending

It is easy for a beginner to abuse blending. This leads to works that are affected and that lack strength. In order to avoid this inconvenience, combine more energetic lineal strokes with blended backgrounds or reduce the use of blending to no more than determined areas of the painting.

Blending can be applied as much to lines that are excessively hard as to large areas of color. In the latter case, colors can be toned down until they vanish from the paper or they can be fused with other colors so as to elaborate a succession of interrelated tones. In order to blend, you can use your hand, a cloth, a paintbrush or with a pastel blender. The latter, however, always eliminates a large amount of the pigment while the hand (and the fingertips) create less dust and give a more immediate result.

1. Apply the color to be blended in parallel strokes without exerting excessive pressure. In this case, a white tone is applied in horizontal strokes. When dealing with a large zone, the color can be extended by using the pastel on its side.

2. To follow, softly run your fingertips over the freshly applied color in the same direction in which the strokes were initially established. This effect should only be given to the part corresponding to the tonal grading and the other areas, in which the strokes are to remain as they were applied, should be left untouched.

3. If it is necessary, a new tone can be applied and also blended down with the fingers over the color previously applied. In this way, a very subtle tonal fusion is created that does not dirty the colors.

Tones

The tone is the grade of color and chiaroscuro particular to each zone of the picture. It is achieved thanks to the extent to which a color, or restricted range of colors, can be graded. Pastel, given its similarity to other determined mediums for drawing, allows for tonal differences to be reflected in a piece of work in a similar way to that allowed by charcoal, sanguine or graphite. This medium, however, has the added advantage of being completely pictorial and of also allowing itself to be used in ways more akin to wet techniques, such as oils.

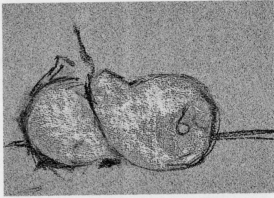

1. The execution of this still life made up of fruits in a restricted tonal range evokes the close relationship that exists between pastel and drawing. In order to carry out this exercise, a gray piece of paper is needed. To begin, over a sketch in a much darker color, apply the first areas of color with the pastel on its side.

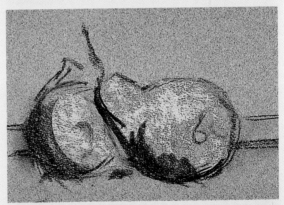

2. Over the first yellow tone, add some dark strokes to define the shadows. To follow, blend the tones together.

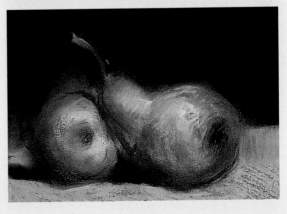

3. Paint the background in a dark tone and the surface of the table in an orangy color. Notice that as we have limited the choice of colors to those from a warm range, all of the colors in the piece maintain a harmony. At the same time, the accentuated contrast between the subject and background give depth to the scene.

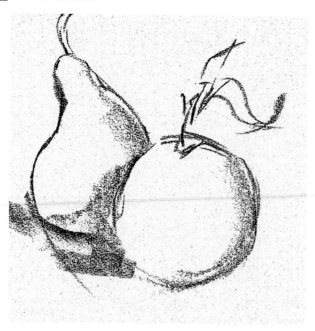

1. The first step, as always, consists in making an initial sketch with the point of a dark-colored pastel. For these initial sketches, pencil pastels can be perfectly well used.

CONTRAST OF TONE AND COLOR

The act of using colors as tones leads to drawings in pastels becoming exercises in modeling with the difference being that the black of charcoal is substituted for a restricted range of pastel colors. The different luminosities of the colors used are what bring the necessary contrast to the drawing to suggest volume. In the following exercise, a simple still life of fruit that possesses a harmony of color is proposed. Notice how the tonal range of this scene runs from the black of the background to the bright highlights of the reflections on the fruit.

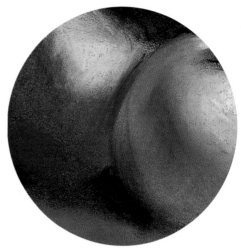

2. Look at the reddish stains that appear in the lower part of the fruits like a reflection of the tablecloth. In this detail, the perfect blending of the tones that model the pieces of fruit can also be appreciated.

3. The felling of depth in the finished work should be attributed to the ample tonal scale used. While the pear in the middle ground seems to blur into the black background, the orange stands out thanks to the reflections on its skin.

COLOR CONTRASTS

In the previous exercise, we developed a theme with an elevated tonal contrast. That is to say, while the colors were limited to those from the same family, the grades of luminosity between the different points of the picture differed sizably. In the following, another type of contrast is looked at: color contrast. In order to define the colors of the different elements of a scene, always bear in mind the adjacent colors and how they interact with the others.

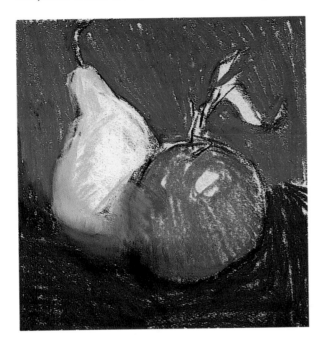

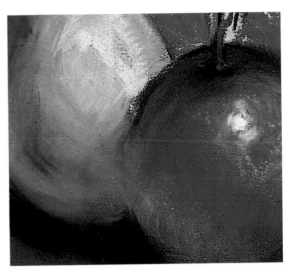

2. In the detail, it can be observed how, in spite of the blended colors in some areas, some parts of this still life maintain evident strokes which leave the support on view and give the work a fresh and energetic aspect.

1. As can be seen, the initial sketch here is identical to the one from the previous exercise. In this case, however, the theme is developed in colors that strongly contrast one with another and that are applied in direct, spontaneous strokes.

3. The combination of complementary colors or others that are very distant on the color wheel lead to an elevated contrast and the tones used seem to vibrate with life. It is important that the colors from different color ranges are not superimposed. A blue can be mixed and blended with another cold color, but this should not be done with a tone from the warm range.

Blending Tones
Seascapes

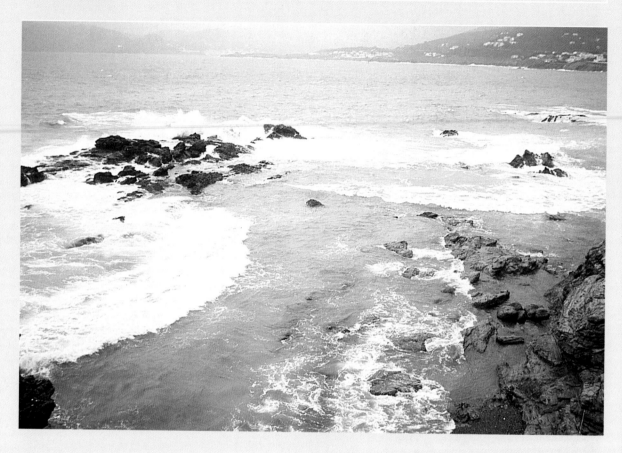

Materials required

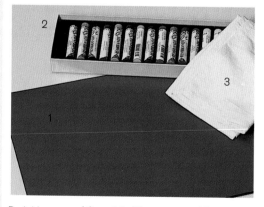

Dark blue paper (1), pastels (2) and a cloth (3).

In order to put the techniques of blending and superimposing strokes into practice, the next proposal is a seascape. In spite of what it may seem by judging from the magnificent final result, this is quite a simple exercise. Here, in addition, the opportunity to combine different techniques is presented. On occasions, the colors will be treated in a misty way and on others, the strokes will be perfectly visible. In this way, the different applications of the medium and the effects that can be acquired with it can be tried and tested.

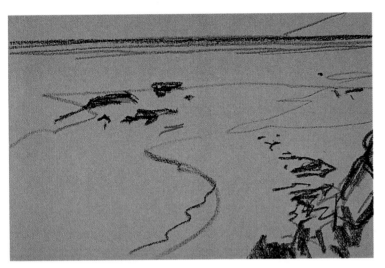

This drawing is based on a photograph in which the line of the horizon lies very high in the composition. The original layout has been respected with the intention of centering attention on the water so we can apply the effects of blending and superimposition of color which we intend to practice in this area.

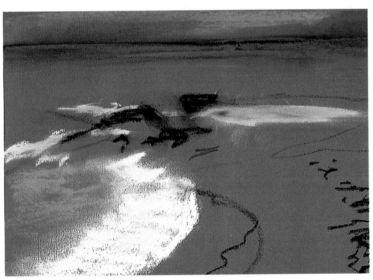

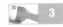

To begin with, paint the border corresponding to the sky in a light blue color. Also start painting in the water in blue and the area in which the waves are breaking with direct strokes in white. Lightly blend this in with your fingers so as to suggest the advancing of the water.

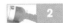

Over the foam of the sea, paint in some blue and blend it in with the previously painted white using your fingers. The margin of the foam is profiled by a greenish tone. Next to this color, paint in some blue and blend in everything. To the right, start to define the waves breaking against the cliffs with loose strokes in white.

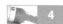

4

From the horizon, a blending of blue tones is created. To do this, marine blue is used. Do not completely cover the paper, but let the color breathe through some of the zones. It can be appreciated that clearly differentiated planes exist that are separated by the horizontal line of foam and the rocks on the left.

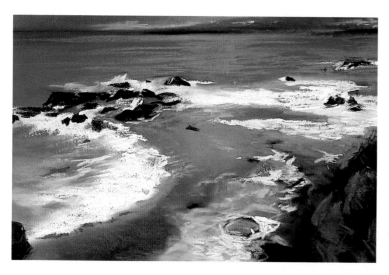

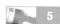

5

Finish off profiling the forms over the horizontal line and lightly blend them in with your finger so as to give a feeling of depth to the scene. In the lower zone, in which the water breaks over the rocks, blend in some white over the background and then insist with some direct strokes again in white.

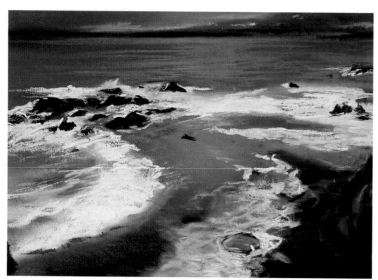

6

Include new discrete interventions of color in the intermediate border between the two areas of foam. Also profile the shadows of the rocks with the point of the pastel. To finish, there is no more to do than add some touches in white so as to draw in the waves.

In order to represent the spirit of the foam of the sea, direct strokes and blending are combined.

The first intervention in white is blended in with the background of tones in blue.

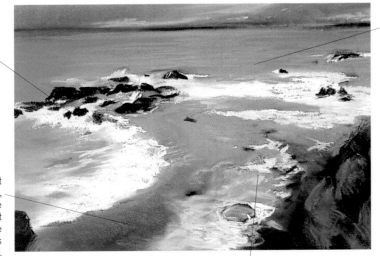

With intermittent strokes in blue, the profile that the waves adopt when meeting the sand is suggested.

Some final touches in white over the water add brilliance and give life to the seascape.

Working a Stroke

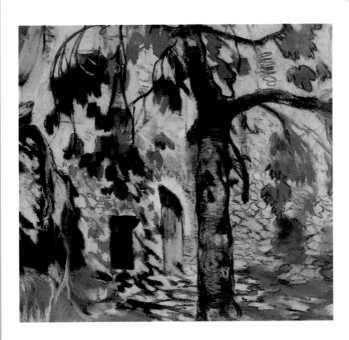

In this work, Mir touches upon his interest in how light filters through trees. In pastels, light colors can be superimposed over dark ones by painting or by using the natural color of the paper itself. This landscape painted in pastel is a clear example of how pastels can be fresh and spontaneous. It is full of color and impacts of light. In this exercise, different ways of painting can be appreciated. Certain aspects have been drawn in perfect detail while others have been suggested with no more than patches of color. The major complexity of this work resides in the structure of the picture not being based on planes, but on patches of color which do not have such an evident connection as in other much more realistic and figurative themes. Above all, the tones of the lights and how the color of the paper is allowed to breathe at all times should be carefully studied.

7 Blending and Outlining

One of the techniques most used when working in pastels is that of blending colors together by rubbing your figures over the painted surface of the paper.

Separation between Colors

The enthusiast should learn to use each technique as it is called for. As a result of being unfamiliar with technique, some develop pictures based on over-weighted blending in which any freshness tends to disappear. Others prefer to draw and draw until the picture becomes a jumble of lines.

There are no tricks when it comes to painting. There is only the correct use of techniques. Here, various examples that deal with the major utilities of pastels, which is to say, how and when to use certain resources, are presented. Some zones should contain blended tones while others, on the contrary, should be made up of strokes and patches of color that are not blended together.

1. One of the themes to which the technique of blending colors gives a favorable result is that of clouds. In this exercise, we propose a landscape which contains mountains and a large mass of clouds in which the pastels are used in a variety of ways: direct strokes in the first case and in the creation of patches of color that are later blended together in the second.

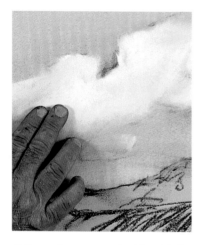

2. Over yellow paper, a cloud is painted in white pastel and it is softly rubbed into the background. The sky has also been brightened with the application of vertical strokes in yellow and lime.

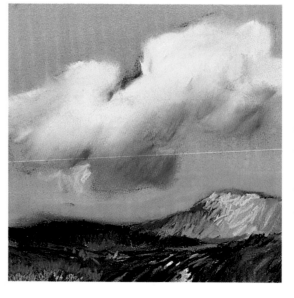

3. The mountain is painted with a succession of patches of color and very direct strokes, which are not blended together, in warm tones. The cloud, on the other hand, is darkened at the bottom in gray to give it more volume. The two techniques used in this exercise go perfectly well together and can be used according to the effect desired.

OUTLINING AREAS

In the previous section, we have seen an initial exercise in the practice of using blending and direct strokes in different areas of the picture. Both ways of working can be combined to strengthen the characteristics of pastel. On this page, an example of how one form of painting can be combined with the other is presented.

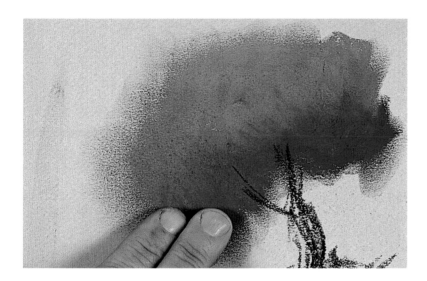

1. In this exercise, we take a tree as a model. Over the initial drawing, the top of the tree is established in green tones that are extended with the fingers. The blending lacks precision in its outline.

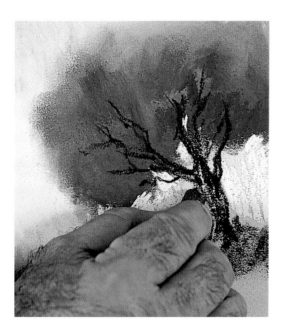

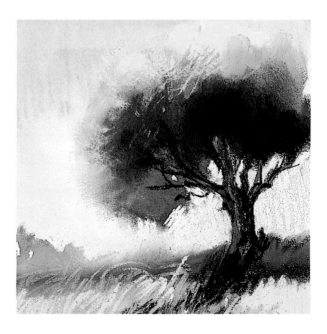

2. Over the green patch, the branches are draw in. In order to help the tree stand out, the sky is painted in pink, which is blended in, and with direct strokes in white. These lines profile the trunk and treetop with greater precision.

3. The ground is painted in earth tones: reds in the distance and yellows in the foreground. In the final result, it can be seen how some direct strokes have been added to the top of the tree and, in the foreground, to establish the grass.

1. Before embarking on the following exercise, it is important to clarify, by means of the drawing, each one of the zones of the subject. In this case tobacco-colored paper has been chosen.

SIMULTANEOUS CONTRASTS

This complex title hides a technique that plays with an optical illusion based on colors and tones which is common to all forms of drawing and painting. In reality, this concept is subject to the laws of optics and the way in which the human eye works. That is to say, when a luminous tone is painted among dark tones and colors, it will appear to be much lighter precisely because of the contrasting effect created by the darker tones. This also happens when a dark tone is painted among lighter ones. The darker hue is seen as being denser. This optical effect can be practiced in this example.

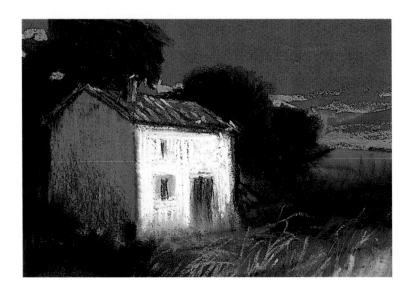

2. The first marks made clearly situate the lightest areas of the scene: the house, painted in white and Naples yellow, starts to stand out among the bushes that have been established in a very dark color.

3. Some wavy strokes in mauve add a little more light to the sky while some green lines recreate the aspect of the grass in the foreground and give greater depth to the piece.

THE EXTENSIVE PASTEL PALETTE

There are many devices that allow the background and subject matter to be compensated and balanced. In this technique, given that the whole work can be very quickly altered with an intervention over the background, color is one of them. On this page, we proposed an exercise in color. In this experiment, the changes to which a form can be subjected by no more than a change in color can be appreciated.

1. For this exercise, we will take a yellow rose as a model. The same flower, which is to be painted in the foreground, will stand out more, or less, depending on the tonality of its background. To begin with, the background is presented in a variation of yellow. The contrast between the figure and the background is minimal although there is a great harmony of light and color.

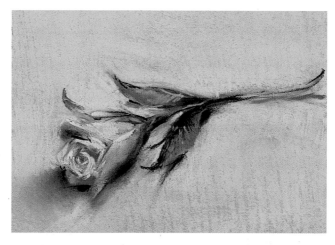

2. To continue, the background is taken to an orangy tone which makes the flower start to stand out a little more. The previously painted yellow has been allowed to breathe through the newly applied color in some areas.

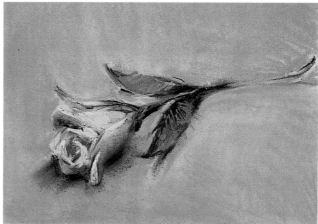

3. Lastly, the background is painted in a red that contrasts strongly with the subject. It is not necessary to completely cover the paper as the feeling of depth is augmented in this way. It can also been seen how the shadows of the rose vary according to the color chosen for the background in each case.

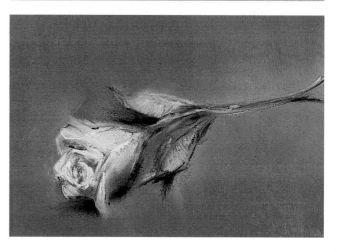

Mixed Techniques

A Loaf of Bread

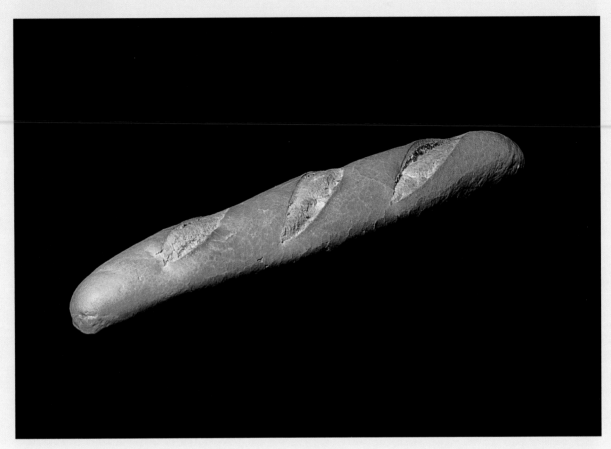

Materials required

Gray paper (1), pastels (2) and a cloth (3)

Painting a simple loaf of bread can be a good way of putting into practice the diverse techniques dealt with in this section. Choosing a good model is always important. However, it should never condition whether or not we paint.

Sometimes, the enthusiast will have difficulty finding an interesting subject. In reality, the humblest of objects can be absolutely valid subjects. In a painting, any well-developed object takes on a new dimension and is worthy of being contemplated.

 1

The sketch is started off in a bright yellow which stands out strongly over the paper. Once the corrections have been made to the drawing, painting in the background is started with the first black strokes that profile the lower part of the loaf of bread.

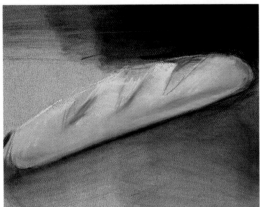

 2

Start painting in the loaf of bread with golden yellow and red tones which should only be blended together in determined areas. In black pastel, start strongly darkening the background with the intention of outlining the form of the loaf. The black is smudged with the fingertips.

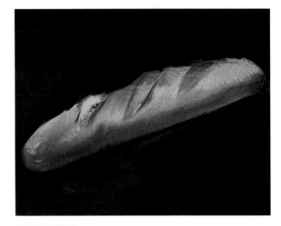

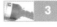 **3**

The background should be almost completely darkened without letting the black affect the internal area of the loaf of bread. This, in turn, is also darkened by blending in ochre colors in the shaded areas.

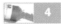 **4**

In this detail, it can be appreciated how important it is that some areas of the painting stay fresh and intact. This is the key to painting in pastels. While some strokes are almost completely blended in, others stay intact during the entire process of painting.

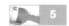

The contrast of the background with respect to the loaf of bread is achieved by means of a fusion of the tones employed. In order to maintain a certain brightness, a stroke in bright blue is made early on over the entire foreground. On the left, there is also a lighter area in carmine and violet.

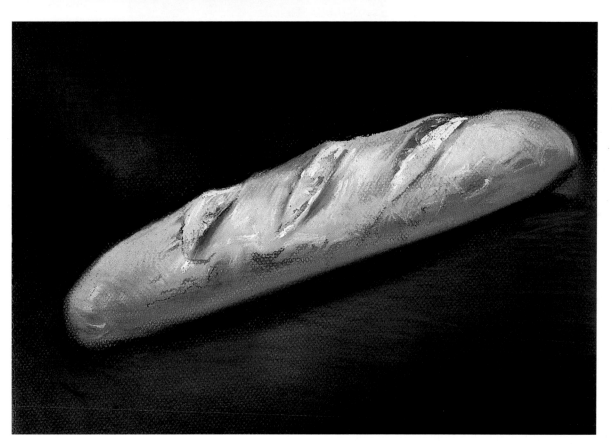

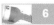

Finally, the upper crust is painted in a light color which contributes to creating the floury aspect of the bread recently taken out of the oven. Also, some direct strokes in red and ochre are added. This makes the bread even crustier.

8 Making the Most of the Background

Being a dry medium, pastel allows the colors previously applied to be seen through those later painted on top whenever a stroke that makes the most of the texture of the paper is used.

The Color of the Paper

The background may appear in a variety of ways: as the original color of the paper before it was painted, as a color painted in a uniform way, or as various colors blended together. Whatever the case may be, an atmospheric effect is created that should be explored and learnt how to use.

When it is intended that the color of the paper becomes the base of the painting, it is important not to cover it completely. The background has to actively intervene among the colors that are later applied and form part of the color scheme as any other color. The result is an atmosphere in which the color of the paper forms part of the light of the model.

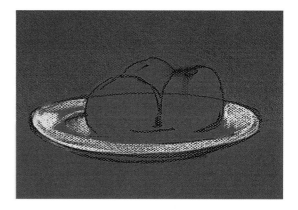

2. Paint the plate around the apples in very light colors leaving the areas where the reflections are to be introduced intact. In this way, the forms of the pieces of fruit are perfectly isolated. Painting in a very bright color integrates the paper as a medium tone.

1. A very luminous red paper has been chosen for this task. A simple theme is going to be developed in order to try out how the original color of the paper acts in an atmosphere in which it itself dominates. An oval form is drawn to represent the plate. On this, the three apples are roughly laid out by drawing some circles.

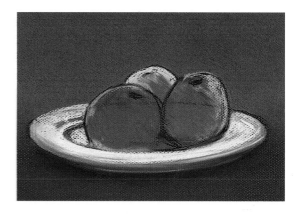

3. In order to complete the fruit, a few punctual reflections that indicate the direction of the light are sufficient. These reflections are painted in a direct way and they can be softened with your fingertips.

THE BACKGROUND OF THE PICTURE

The background of a picture can be established before the principal subject is worked on. This way of working may well become an habitual procedure in some forms of painting in pastels especially when there is a certain complexity about the background such as a texture that may be altered by the situating of the principal subject of the painting. Pay special attention to the stage in which fixer is applied in order to make the background more stable before the layers of color that define the subject are added.

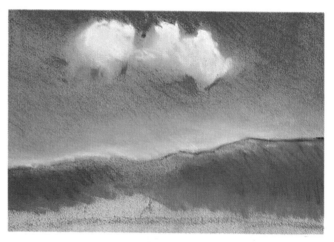

1. In the background, all of the zones that correspond to the overall atmosphere, including those of the hidden parts of the picture, are painted in. What really interests us here is establishing a good base over which we can paint the main theme. It could be imagined that this first part of the exercise is like creating scenery. As the principal elements, the sky and the mountains, do not as yet exist, the background can be worked in complete comfort.

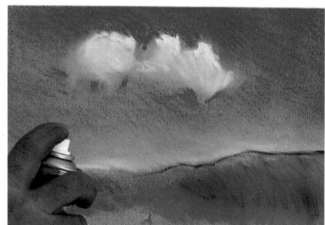

2. Once this first part of the exercise has been completed, the work carried out is fixed. Apply a very light coat of fixer from a distance of some 30 centimeters that does not lie heavily over the colors. From now on, the background will remain the same and will serve as a base for the elements to be included in the foreground.

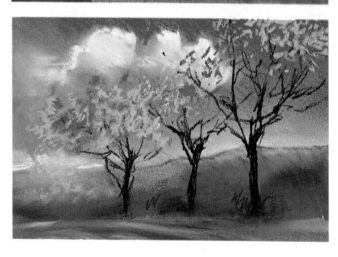

3. The fixer has to be allowed to dry before beginning work on the elements that make up the landscape. Corrections made during this phase of the work are not going to affect the colors previously applied as they have been fixed. The foreground is painted in with trees and the rest of the elements that make it up. The background appears well defined through the branches of the trees.

SUPERIMPOSING AND THE BACKGROUND

In addition to the simple devices available to us for dealing with the background and the subject in pastels, there are many others, based on the techniques of superimposing and blending tones, which give spectacular results. As a result, it is possible to make the subject stand out by means of the blurring of the background. In this case, it is a question of establishing the center of interest of the picture and learning how to make the other elements stand out.

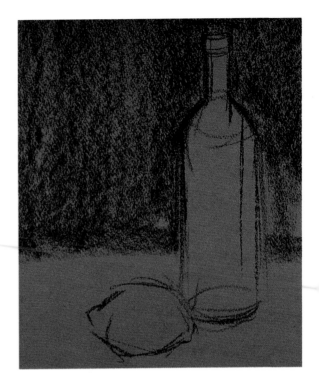

1. A simple composition has been taken as a theme that should stand out over a dark background. From the beginning, the strokes made in order to paint the background outline the elements of the picture.

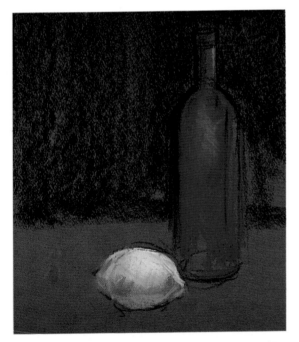

2. Blending together the strokes that make the background is one way of making the principal elements stand out more. Special care should be taken here when rubbing your fingers over the painting so as not to spoil the forms of the principal elements.

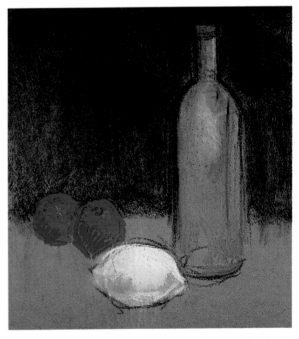

3. In order to increment the contrast of the apples painted in the middle ground, darken the background even more by adding another layer of black pastel. The darkening of the background helps the elements in the foreground acquire luminosity.

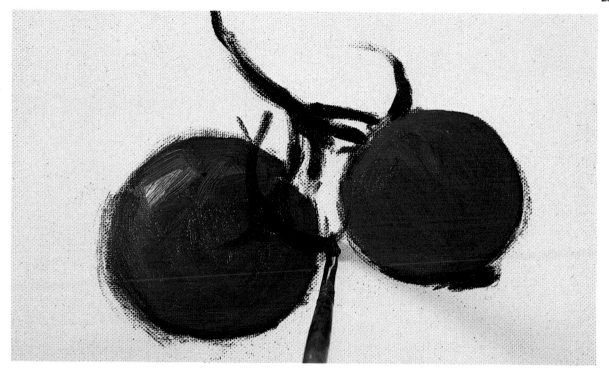

As in the previous exercise, the details are only put in when the large masses of the picture have been completed.

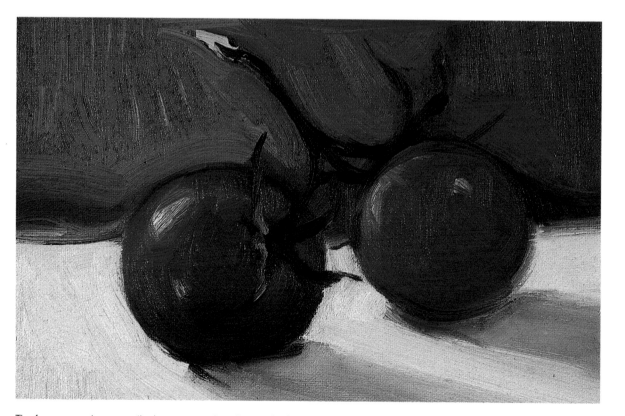

The forms are redone once the large masses have been solved.

The underpainting
A garden

Materials needed

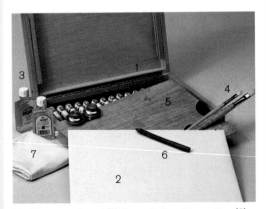

Oils (1), canvas board (2), linseed oil and turpentine (3)
brushes (4), palette (5), charcoal (optional), cloth (6).

The subject to be developed in this exercise is a
pond in an abandoned garden.

The model should always be to the artist's liking
since it will otherwise lose part of the picture's incen-
tive. In this case, the composition is simple, comple-
tely symmetrical and elliptical.

The large masses of green around the pond establish
nice contrasts that make their interpretation simpler.

 1

The sketch of the pond can begin in charcoal to lay out the first zones of color. But immediately after this the whole sketch should be done in a highly thinned neutral color (this will erase the charcoal). The form of the pond appears as an ellipse due to the effect of perspective. This shape should include the columns ranged at regular intervals and the backdrop of trees.

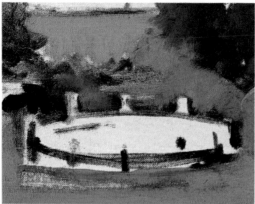

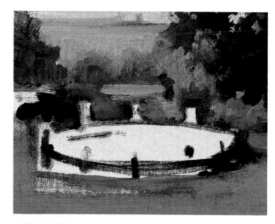

 2

The first color strokes should be a large mass of bright green around the pond. As you can see, in this step it isn't necessary to get textures or tonal variation. Just cover each of the main areas of the picture.

 3

Now you can paint over the underpainting. Use new nuances from now on, dragging part of the color underneath. The ochre will take some white. The paint being laid on will mix with the previous painting.

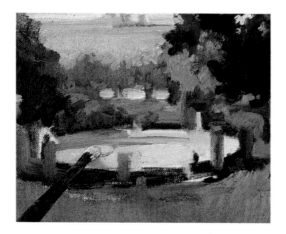

 4

Complete this layer with the vegetation on the left. Then start the grass in small brushstrokes superimposed on the general green previously applied. Use short strokes in white in the background. The pond should begin with the columns in yellow grayed with green; the insides of the columns are ochre and green

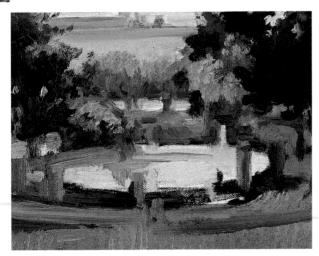

As you can see, no details should be added until the general area is sufficiently covered with large masses of color. Once these masses have set the scene, lay on textured strokes or change the form, contrast, or even the color.

On the most highlighted tree on the right you should use almost pure yellow with small brushstrokes that mix with part of the color underneath. Small brushstrokes should also be used on the left, but in more muted tones.

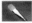

Oil can be touched up at any moment. The columns just painted can be redone until you have the desired form. Here it's best not to paint the inside of the pool since the ochre should remain bright.

Once you finish this area, add some detail in red to the column at the back to present the wildflowers.

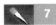

Paint the definitive contrasts of the pond. Do the columns first in grayed tones with blue in the shadows. The highlights should be done last in very careful strokes.

The border of the pond should be in a neutral value that contrasts strongly with the inside, which is left bright. Finish the contrasts in the terrain and vegetation in the bottom third of the canvas.

Finally, paint some defining strokes for the arcade in the middle distance.

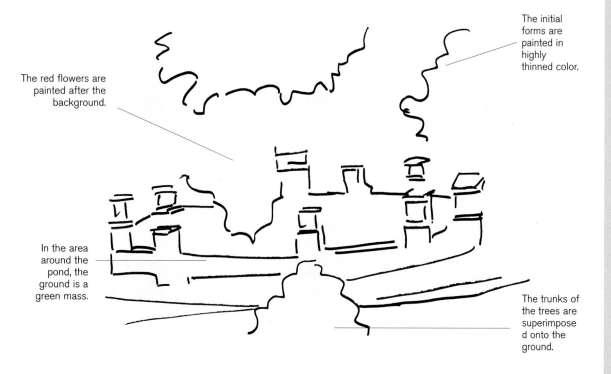

The initial forms are painted in highly thinned color.

The red flowers are painted after the background.

In the area around the pond, the ground is a green mass.

The trunks of the trees are superimposed onto the ground.

The underpainting as contrast

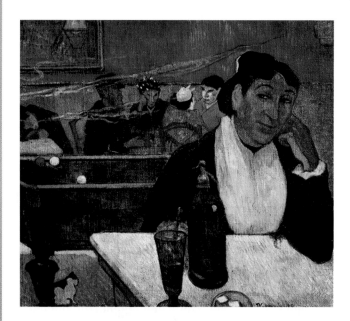

Paul Gauguin (1848-1903) developed a technique with such a personal touch and with such pictorial force that his style came to influence one of the Post-Impressionist movements which, even today, is the style of many artists: Fauvism. The name was bestowed by a critic who used the expression "la cage aux fauves" (the cage of the wild beasts) to refer to one of the rooms in the 1905 Autumn Exhibition and the paintings in it.

While originally disparaging, the term fauvism became an accurate description of the visual effect produced by this painting over large areas in great contrast. The piece by Gauguin shown here, Café d'Arles, in the Pushkin Museum in Moscow, like many of Gauguin's other works, is made up of large masses of color the painter enriched slowly with multiple chromatic nuances.

8 Light and shadow

When painting in oil, color values can be interpreted as light values, that is, the lower intensity of light corresponds to a more muted color. The scale of brightness covered by a determined color range is thus comparable to the chiaroscuro you can obtain with charcoal or with a thinned neutral color. Therefore, such a scale is adequate for representing the lights and shadows of the object to be painted.

The tones of the colors

Painting in oil rapidly replaced painting in tempura, and one reason for this is the slow drying time, which permits more meticulous work.

The oil technique aids color fusion and enables tonal gradation with a subtlety that makes it impossible to say where the change from one color to another begins.

Although you already have rather a good knowledge of color, in this unit we'll center our attention solely on the problem of light and shadow. In the exercises that follow, a monochromatic range will be used to address this issue.

Brushes

The brushes that can be used for oil painting vary according to the part of the process being developed. To paint the toned ground (stain), use the widest brushes, either flat or "cat's tongue". The most frequently used brushes in oil painting are hog bristle and synthetic. The texture of the brushstroke naturally depends on the bristle quality: the softer this is, the less texture it will leave.
Flat brushes make straight lines with well-defined borders possible. Cat's tongue brushes make more precise strokes easier.
Round brushes help with lines and with given types of strokes.

LIGHT AND DARK TONES

The darkest tones are those of the shadow or parts of the penumbra. If the darkest tone used in a picture is a mixture of Van Dyck and burnt umber, the rest of the values used should not go beyond that maximum, which will be understood to represent black.

Something similar occurs with light tones. Whatever the lightest tone used, it will establish the most luminous limit which (if bone white is the maximum for luminosity in the painting) will be what is applied only in the lightest zones. Therefore, you should carefully establish what the limits in value gradation will be both for light and dark colors.

STUDYING THE MODEL

Prior to beginning to draw and paint study a real model to see how the shadows fall in the different areas. To do this, set up a simple still life with a piece of fruit such as an apple.

In this example we've used an apple with a wrinkled peel to show a less shiny texture, thus allowing us more easily to locate each of the parts of the light and shadow. On the right-hand side of the apple is a square of white cardboard that serves as reflector and wall at one and the same time. The light source is on the left so that the apple's shadow is projected onto the cardboard. And thus we observe different areas of light. One part of the apple is clearly illuminated and there we can appreciate a maximum point of luminosity. The rest shows a more muted tone or one of indirect lighting, and in the shadow area different tones are perceivable. Beside the shadow the apple casts on the cardboard, in the outline delimiting the background, is a reflection produced by the white color of the cardboard. The deepest and darkest shadow is that projected onto the cardboard—the zone of projected shadow.

THE CHARCOAL SKETCH

To represent the shadows, the most important thing is to know where they must be situated. There is no better way to do this than by charcoal sketch, a technique that makes instant correction easy and enables detailed study of each area of the picture. After sketching the form of the apple and the cardboard wall, draw the shadow that is darkest: the projected shadow.

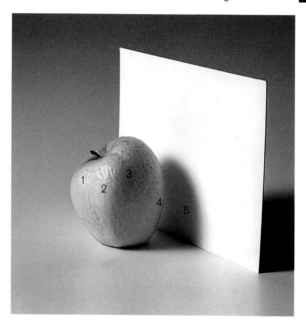

Look carefully at the apple. The wrinkled skin shows different light tones: a maximum point of luminosity (1), a zone of indirect lighting (2), the shadow zone proper (3), the zone of reflected light (4), and the zone of projected shadow (5).

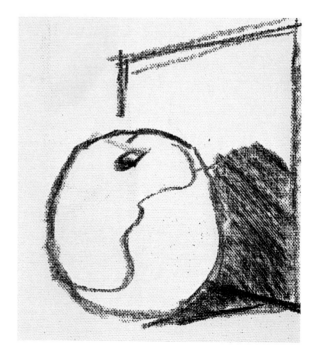

Sketch the apple and draw the zone of the projected shadow. This shadow outlines the form of the apple. The projected shadow is the darkest zone.

First, paint the darkest tone of the picture, the projected shadow. The zone of the shadow proper is painted in a slightly lighter tone in the same color range.

THE FIRST BRUSHSTROKES

The first brushstrokes can be laid on thickly. With these we begin to paint the area of darkest shadow, that is, the zone of the projected shadow. In this part of the painting you'll establish the darkest tone of the still life. Forget about using black and instead lay dark colors like burnt umber or dark brown: these tones will provide a deep contrast rich in tones. The shadow area proper is the next to paint. First, use the same dark tone to delimit the zone of indirect light and bring out the effect between the simultaneous contrasts. In the interior of the shadow paint in a lighter tone (the contrast with the background is obvious). Paint the background slightly with the same color used to develop the apple's shadow.

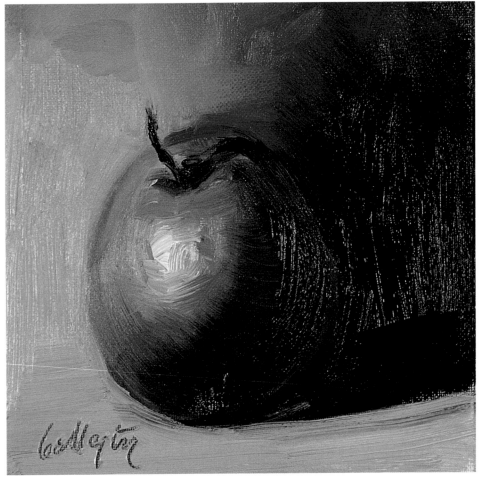

In this detail you can appreciate how the zone of indirect light is developed and the point of maximum luminosity. En treating the lights and shadows, the brushstroke acquires a special importance.

The sketch may be done in charcoal, which allows immediate correction.

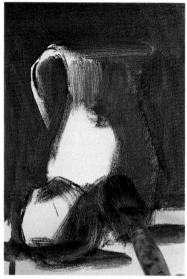

The main area is outlined by the shadow zone proper.

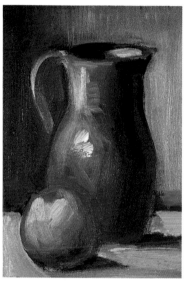

The texture of the objects painted creates a highlight whose brightness is directly proportional to the brightness (shininess) of that texture.

SEPARATION OF TONES

The values of the highlights and of the shadows are planned in a slightly different way. But inside each zone different gradations of light are also established. In the area of maximum luminosity is a point of highest luminosity. This point must be painted last in order to keep from contaminating other darker areas. The rest of the light area has to be developed with a slightly more muted tone. When you paint these areas, you'll immediately come into contact with the part destined to represent the shadow. This is when the brushstroke becomes especially important.

The treatment of the line enables blending of light zones with shadows. Take some care with the limits of both areas, otherwise one tone will invade the other(s). The brushstroke is a way of configuring the shadows according to the plane required in each area.

CONTRAST

In the first exercise we were able to lay the first contrast thanks to the use of charcoal. In the present exercise, we'll go in directly with thinned paint. Use burnt umber for the backdrop, taking care to define very well while outlining the main forms of the still life and the edges of the table. Use burnt umber and a rather thick brush to paint the shadows of the two elements in the still life. As your strokes grow drier, don't reload the brush but use the paint left to create your midrange tonal values, above all when painting close to light areas in mergers.

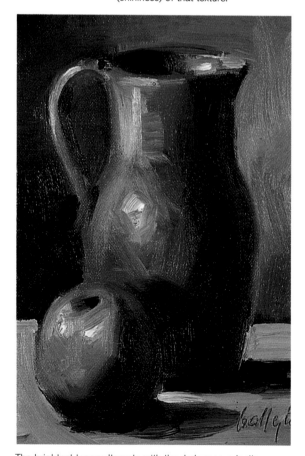

The brightest tones alternate with the dark ones, adapting themselves to the objects' facets. The shadows fuse with the light areas in the zone of indirect lighting.

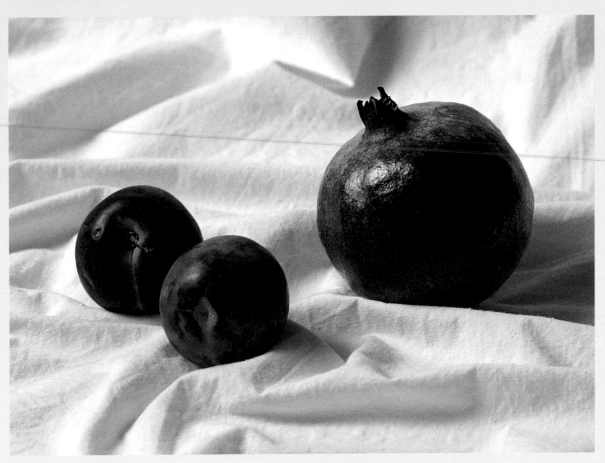

Materials required

Canvas board (1), oils (2), linseed oil (3), turpentine (4), brushes (5), cloth (6).

While previous units discussed the subject of lights and shadows, only now have we studied this in detail. The model proposed here is again not complex, either in terms of drawing or composition. Its forms are basic, all three being rounded. And the study of the shadows will thus be elemental and simultaneously provide basic notions in understanding the shadows of more complex elements.

To simplify the question of color, the palette has also been reduced. Thus, if you follow the steps set out below, there should be little difficulty in solving this interesting still life made up of three pieces of fruit.

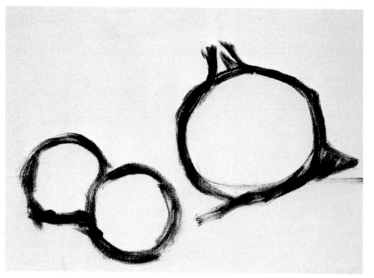

The structure of these elements is so simple that the drawing requires little more work than a sketch directly in oil. Use rapid strokes to sketch the three pieces of fruit. If necessary, correct anything you don't feel good about by wiping the paint off with your cloth and redoing the line without erasing the stains.

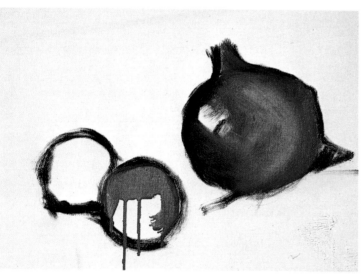

Once you have a rapid sketch, plan the first tones. For the gray, use a mixture of dirty colors from the palette plus turpentine. If your palette is clean, the gray can be made of green, umber, and white, a pretty fair equivalent.

Using violet-carmine, paint the most highly illumined area of the pomegranate, leaving the point of greatest luminosity unpainted.

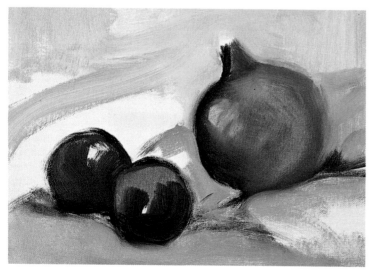

Also use the same violet-carmine to paint the plums. The gray area of the plum on the right serves as separation space between the two fruits. In the pomegranate, make various passes over the surface with your brush to fuse colors and begin to bring out the spherical form.

For the whitish areas, mix white, violet-carmine, green, and blue.

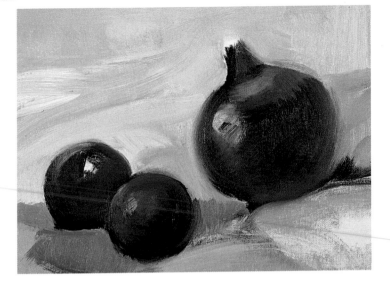

The spherical form of the pomegranate is brought out using curved strokes. Begin to separate the light areas in the plums with couches of dark violet mixed with a little cobalt blue. The blue touch painted beside the highlight in the shadow zone of the plum on the left will be fundamental to an understanding of its shadow and, obviously, its volume.

With cobalt blue and ultramarine, paint the part of the tablecloth closest to the viewer.

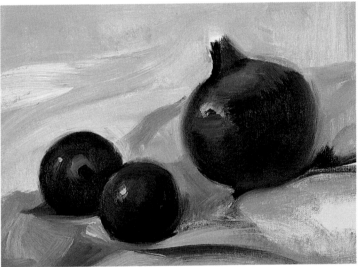

This step requires some attention. It is a question of planning the main differences between the lights and shadows. The light source illuminates from the left. Thus, the most accentuated shadows must be located on the opposite side. Give the upper surface of the plum on the left a striking touch of carmine. On the right of the same plum, the colors tend to be cold, bluish; but on the left-hand side they are much warmer.

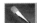

Enrich the luminous areas of the pomegranate with orange tones that contrast with the pure carmine. To get the luminous tones from carmine and from red without having them become pink, intensify the tone not with white but with Neapolitan Yellow.

The shadows of the plums in the end completely define the spherical form.

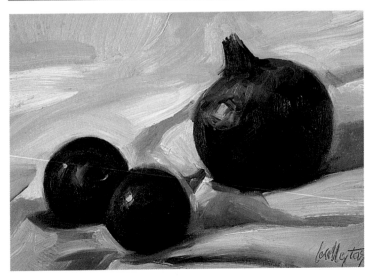

The highlighted area of the plums and of the pomegranate are left unpainted to serve as a differentiating point of reference.

The light areas of the pomegranate are done in colors intensified with white and with Neapolitan Yellow.

Plan the dark area of the plum with dark violet and cobalt blue.

Use a very thin gray color to paint over the pomegranate and the plum on the right.

The initial sketch is done in thinned paint.

A realistic exercise

In the still life shown here, quite simple in composition, the Post-Impressionist painter of genius Odilon Redon (1840-1916) shows off his technical knowledge.

Redon uses an expressive realist treatment of the light, with an in-depth study of the relation between the colors and the effect produced by the complicity between the shadows and the reflections. Observe how the light source is on the right-hand side, just above the viewer's head.

9 Pictorial planes

Oil enables a large number of resources for painting all kinds of subjects with great technical accuracy. Painting in this medium can be seen as a wholly two-dimensional question where depth has no plastic value.

Dealing with planes

In the pages that follow we intend to provide a series of very useful resources to make it possible to plan paintings where the elements are laid out logically. From the general treatment of the canvas to the use of the brushstroke in accordance with the planes of the picture, passing through the lighting of each facet, the notions taught will serve to guide any further work.

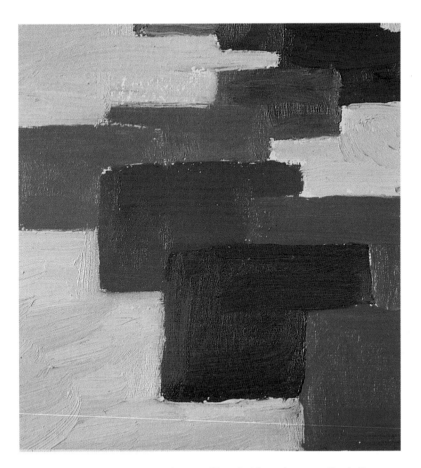

In this schematic oil painting note the natural layout of the colors according to the planes in the distance. The warmest tones correspond to the closest planes.

DEFINING PLANES IN OIL

Planes correspond to each of the zones an object occupies in space. But planes also refer to the representation of each of the zones of the object with respect to its situation in the observer's view. For example, in the graphic shown on this page each of the areas painted with a color represents a plane, and each plane occupies a space on the canvas. When an object is painted, the process will also take into account the planes in the space. Each of the facets of the object will be presented in a different plane, and the treatment will be in accordance with color or brushstroke.

PLANNING THE PICTURE

The picture should be entirely understood as a succession of objects situated in different planes. Logically, in the same space occupied by one object, no other object can be situated. Thus, we observe that some objects are closer and others farther away. Moreover, those that are in the same plane are perforce in an adjacent arrangement.

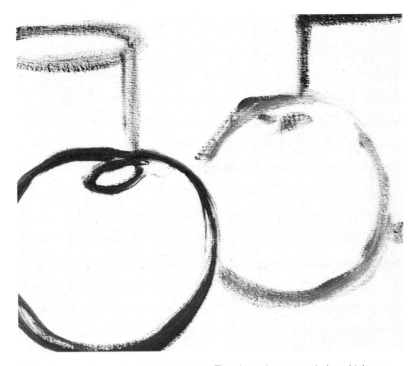

From the first moment, planning the painting makes us observe the placement of objects, i.e., the way they are situated, the distance between them, and the slope of the ground (always according to the observer's point of view).

THE FIRST STEPS

Try this simple exercise on treating situational planes. It is based on the graphic shown on this page, where the foreground is represented by a red sphere, the middle distance by an ochre sphere, and the background by different shapes in earth tones. The still life proposed will be panted from these elements.

In our present study, the first plane or foreground is begun with a red object,

Each plane has its own height in the picture. The elements represented are higher as their distance from the viewer increases.

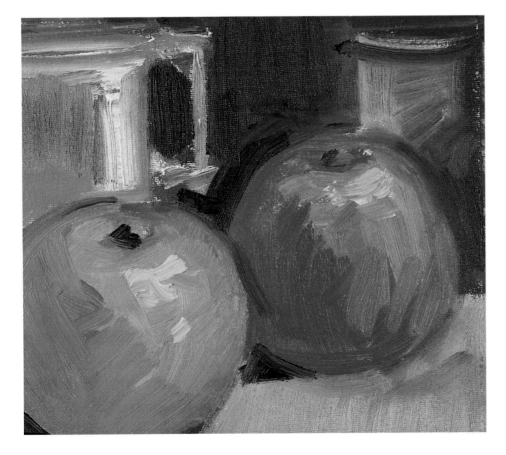

The creation of the foreground or first plane is done in more detail than the remaining two thirds of the painting.

the sketch being done rapidly and directly to create a circular form that will later show itself to be a piece of fruit. Use thinned color for this so that the color runs easily onto the canvas (board). In the next plane (the middle distance), above the first, draw an orange spherical form without detail. Finally, in the upper third of the canvas, in an earth tone, draw two containers schematically. Now note carefully what you've done: each plane has its height on the canvas.

THE MAIN PLANE AND THE BACKGROUND

The main plane has the greatest protagonism in the picture. It isn't necessarily the center of attention, but its treatment receives greatest protagonism, both in terms of size and brushstroke or color.

WAYS OF SEPARATING PLANES

We've just observed how planes separate in the piece according to distance, which is represented by the height of the main object. The treatment of objects according to brushstrokes and color also distinguishes the planes that occupy the objects painted.

INCREASING CONTRAST IN THE MAIN PLANE

The main plane is always the ruler in the composition. From this, the remainder of the objects are located. The first planes or foreground always contrast with the later planes to keep the planes from appearing to cling to each other.

At this point, let us paint another still life. The foreground will be painted first so as to represent the later ones with other tones. Hence, a contrast will be established between the foreground and the other two major planes. The outlines of forms and color changes

The foreground is solved by using warm, highly contrastive tones, in impasto.

The shape of the foregrounded objects is more clearly defined than that of the second plane which, along with the colors between one plane and the other, powerfully separates the two.

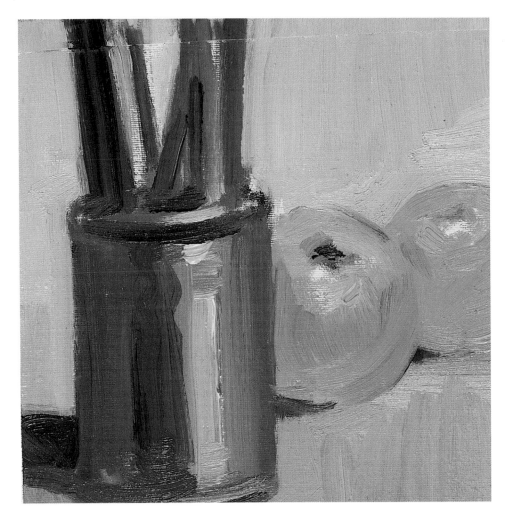

After painting the last planes, the forms fuse into the background via successive brushstrokes blending the shape with the color around it.

The forms painted in oil can be outlined or simply insinuated very free brushstrokes that intermix with the background colors. The foreground is perfectly separated from the background by its different tones.

THE OUTLINES OF FORMS AND COLOR CHANGES

The forms painted in oil can be outlined or simply insinuated very free brushstrokes that intermix with the background colors. The foreground is perfectly separated from the background by its different tones.

BLURRING BACKGROUND FORMS

To increase the difference between the different planes of the picture, you can use a still more powerful technique than the previous ones. It is a question of blurring the forms of the objects situated in other planes. Oil is very thick and enables the application of fused strokes merely by caressing the previous layer of paint.

THE RELATION OF LIGHT WITH THE DEEP PLANES

The placement of the different objects in the composition makes it possible to lay out different possibilities in terms of painting the highlights. "The light that touches objects can be used as a resource to favor the closeness or distance of the planes they occupy. While the highlights on the model may be similar, you can interpret differently and treat differently these reflections in the different planes.

THE HIGHLIGHTS IN THE FIRST PLANE

The most important highlights are treated as direct impacts of color or as pure reflections. The direct impacts are applied with free brushstrokes, without muting the color. To paint the main plain, plan both color and lighting simultaneously. The contrasts will be strong and promote the play of com-

plementary contrasts, bringing out dark colors with light tones and vice-versa.

THE UNDERPAINTING IN
THE SECOND PLANE

Prior to painting the second plane in a definitive way, establish its zone of light and its zone of shade. In the process, there will still be no separation between the planes, although a much more finished foreground will always favor this idea.

SEPARATING THROUGH
HIGHLIGHTS

The highlights just painted in the foreground are intense, charged with color and light.

On the other hand, in the second plane there are also highlights but these are much more monochromatic, far from showing great contrast with the other tones of the object.

The light to be painted on this object in the middle distance of the picture is muted and charged with attenuating nuances of reflection. Pure colors are not used but mixtures off the palette using tones like those in the background.

COLOR IN THE PLANES
OF THE LANDSCAPE

To create the effect of depth on the canvas, one possibility is to dispense with the details of the upper third of the picture and to increase the contrasts in the areas closer to the viewer.

OIL MAKES IT EASY
TO INSINUATE FORMS

More than with any other pictorial medium, oil enables very good summaries of forms via a small brushstroke.

Using this characteristic to advantage, the planes of the far distance can be approached very synthetically, using colors far less contrastive than those in the foreground.

In the first plane, general colors and more direct lights are planned.

In the plane in the far distance, it's also necessary to establish which zones are lighted in order to continue using color in them.

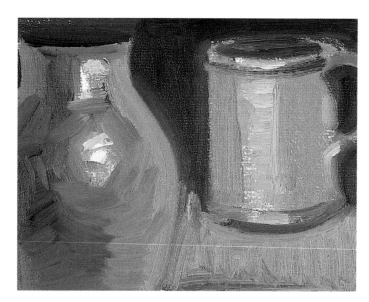

The highlights in the back planes lack the luminosity of those in the foreground.

A PHOTOGRAPHIC EFFECT

When we observe a photographic image the most distant planes appear out of focus. In painting we can use this same effect to solve the far-off features. The closest facets can be painted in very warm colors and with increased contrast.

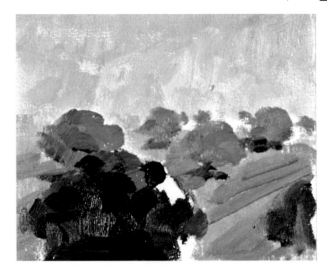

The areas or planes farthest from you are presented using smaller sizes than those that are closest. The forms are insinuated with fresh, direct brushstrokes. As the trees closest to hand are painted, the amount of contrast and the purity of color increase.

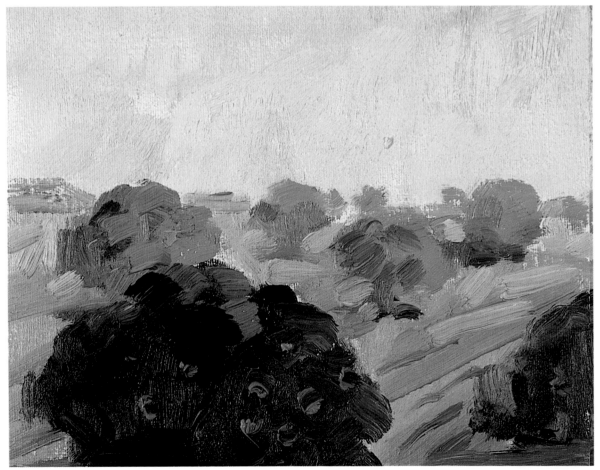

Working with planes

Bottles and Tablecloth

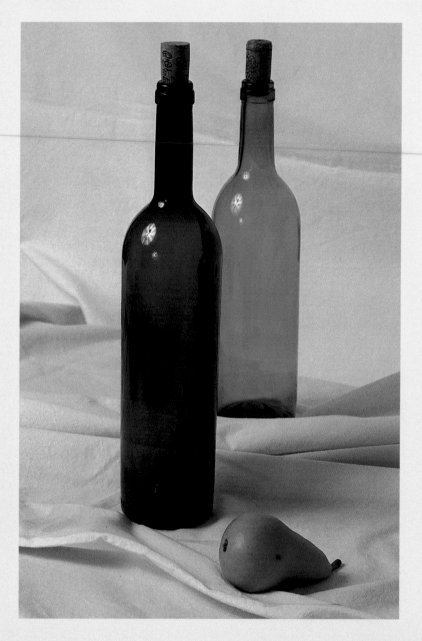

Materials required

Oils (1), palette (2), turpentine and linseed oil (3), cloth (4), canvas board (5), charcoal (6), oil brushes (7).

The layout of the different planes of the painting is not a question that can be learned in a moment. However, it is possible to get an approximate idea of the technical treatment with a few practical guidelines. In the previous units we've studied how atmosphere is represented with oil. The layout of the planes of the picture has to do with the atmospheric effect only as a technical question. The planes closest to the viewer are more defined than those in the distance, and this is a question that must be taken into account. Each of the different facets of the canvas requires a different treatment, both in terms of brushstroke and in terms of color.

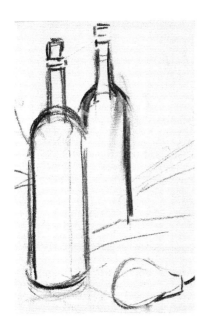

The sketch contributes to the representation of the different planes of the picture because it defines the position of each of the elements portrayed.

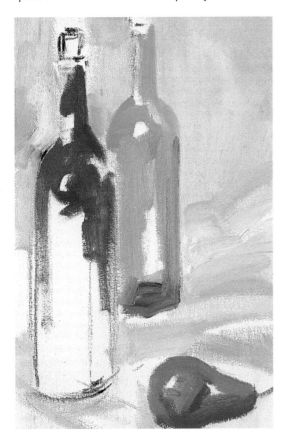

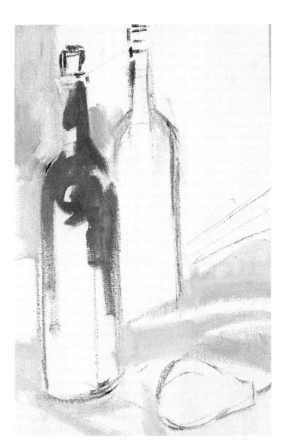

The underpainting is begun by painting the bottle in the foreground with a mixture of sienna and English Red. The mixture is not produced on the palette but by loading a little of each color and mixing it directly on the canvas. Drag of the brush loaded with one color over the other. While painting this bottle, leave blank the areas corresponding to the highlights! These will be painted later.

Begin to paint the area corresponding to the background, using blue lightened with white.

To finish the bottle in the foreground: a) use long strokes next to each other on the neck and the body; b) use natural sienna on the left-hand side; c) use sienna toned with a bit of burnt umber in the center; and, d) toward the right-hand side, paint in a little English Red grayed with sienna.

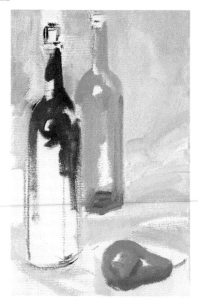

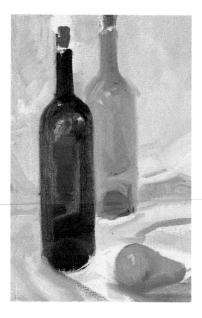

Use dark brown on the neck of the bottle, painting in long vertical strokes. In the center, the brushstrokes are short and horizontal, creating a different plane.

In the body of the bottle, create new planes (in the center, using short horizontal strokes of red; in the curve, using orange in strokes that follow the form; in the highlights, using yellow.

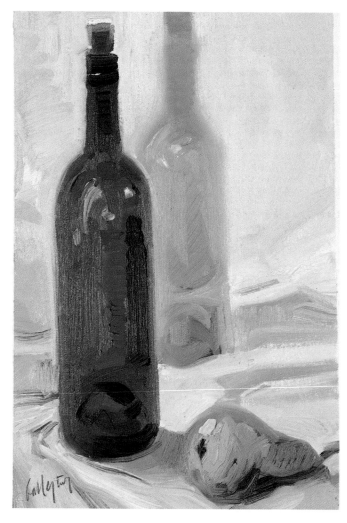

The work on the wrinkled tablecloth is simple but requires greater attention in the foreground than in the background.

The light tones in the foreground are much brighter and purer that those in the back plane.

Use very soft brushstrokes to eliminate the outlines of the bottle in the background, which will give it an unfocused appearance. This should close the oil painting using planes.